09/24
STRAND PRICE
$ 5.00

ROY STRYKER: U.S.A., 1943–1950

The Standard Oil (New Jersey) Photography Project

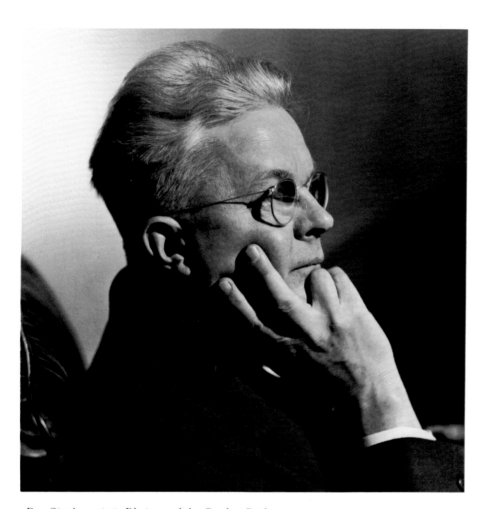

Roy Stryker 1947. Photograph by Gordon Parks.

ROY STRYKER: U.S.A., 1943-1950

The
Standard Oil
(New Jersey)
Photography
Project

By
Steven W. Plattner

Foreword
by Cornell Capa

 University of Texas Press
Austin

Library of Congress
Cataloging in Publication Data

Plattner, Steven W. (Steven Wright), 1953–
 Roy Stryker, U.S.A., 1943–1950.

 Includes catalogue for the exhibition en-
titled, Roy Stryker, U.S.A., 1943–1950, held
at the International Center of Photography in
New York.
 Bibliography: p.
 1. Photography, Documentary. 2. United
States—Social life and customs. 3. Stryker,
Roy Emerson, 1893–1975. 4. Photographers—
United States—Biography. I. Stryker, Roy
Emerson, 1893–1975. II. International Center
of Photography. III. Title.

TR820.5.P57 1983 779′.9973917 82-23886
ISBN 0-292-77028-6

Requests for permission to reproduce material
from this work should be sent to:

Permissions
University of Texas Press
Box 7819
Austin, Texas 78712

Contents

This book is for
Clare Hattemer Plattner
and is written in memory of
Fred Joseph Plattner.

<div style="border: 1px solid black; display: inline-block; padding: 20px;">

Foreword

</div>

by Cornell Capa

Executive Director
International Center of Photography

ROY STRYKER began his career as an educator at Columbia University. In his economics class, he used photographs to convey to his students the connections between economic theory and world reality. When Stryker left Columbia in 1935 to join the Roosevelt administration, he took with him the knowledge of photography as a teaching/learning tool and went on to make a profound impact on America's photographic heritage.

Because of his early understanding of photographs as historical visual documents and due to the confluence of unique opportunities and organizational genius, he was to usher into existence a solid social record of the United States during the momentous years 1935–1950. The two major portions of this work are the project sponsored by the Farm Security Administration (FSA), 1935–1942, and the one commissioned by the Standard Oil Company of New Jersey (SONJ), 1943–1950.

A good deal has been written about Stryker in connection with the FSA, and many images of that period became known to the interested public. For various reasons the SONJ collection, to date, has not received equal attention.

After the disbandment of the FSA and during World War II, Stryker collected a select group of photographers who photographed the sights of life that "the boys" left behind. The home front was a busy place with men and women working to produce the needs of a nation at war. It was a period of transition from a rural to an urban culture, a very specific period for talented photographers to capture on film.

In Stryker's own words:

The question is not what to picture nor what camera to use. Every phase of our time and our surroundings has vital significance and any camera in good repair is an adequate instrument. The job is to know enough about the subject matter, to find its significance in itself and in relation to its surroundings, its time and its function.[1]

Stryker was a visionary and a pioneer. His attitude toward photography can be further summed up as follows:

1. He believed that photographs can be eloquent because through them one can share the compassionate and often passionate understanding of the photographer.

2. He believed that photographs can influence and alter people's thinking.

3. He encouraged the development of the picture essay, a photographic narrative, a story which was more than an accumulation of individual images.

Due to the interest and dedication of a young photographic historian, Steven W. Plattner, a thorough study of the SONJ collection has been undertaken and now makes its appearance in this book and in the exhibition "Roy

1. Roy E. Stryker, "Documentary Photography," in *The Complete Photographer*, ed. Willard D. Morgan, vol. 2, no. 21 (April 1942), p. 1368.

Stryker: U.S.A., 1943–1950," where the work of each photographer is presented in an abbreviated individual essay form.

Plattner's text and the chosen images from the body of work will give you a fair idea of the stated origins and purpose, as well as the present importance of the collection. I would like to add a few words about the photographers. The face of the country, our way of life have changed much, but their vision as seen in their photographs remains fresh, unstilted, and believable. It is equally interesting to note that their names continue to occupy the first ranks of documentary photography as well as photographic history.

We may all rejoice that Stryker took on the SONJ project, that he had good luck and judgment in picking his team, that the University of Louisville preserved the collection, that Plattner chose to research it, and that the University of Texas Press has published the book. As a result of all this, an era of American history previously little known, understood, and remembered will be brought to the attention of the public. The International Center of Photography is privileged to present the exhibition nationally on a grant from the Exxon Corporation.

Preface and Acknowledgments

THIS BOOK is both a history of the Standard Oil Company (New Jersey) photographic project and a catalog for the exhibition "Roy Stryker: U.S.A., 1943–1950" organized and circulated by the International Center of Photography. In the introduction I have tried to emphasize the origins of the Standard Oil project, the similarities and differences between Roy E. Stryker's Farm Security Administration historical section and the Standard Oil project, Stryker's role as a director of photographers at Standard Oil, his emphasis on the "picture story" style of coverage, and the extraordinary degree of interpretive and aesthetic freedom that the company offered Stryker and that Stryker, in turn, offered the project photographers.

Biographical essays about and photographs by the twelve major Standard Oil photographers are arranged in the order in which they joined the project. For the most part, the photographs accompanying the biographical essays were chosen to reflect the photographers' varying styles and to present work from many of their finest assignments.

Following the biographical essays is a series of single images by several Standard Oil photographers. On their assignments, the photographers were encouraged to photograph virtually anything of interest to them. They created hundreds of photographs of high aesthetic and historical merit. This section of the book, therefore, presents a selection of photographs which stand by themselves as works of artistic or historical merit. Besides offering additional images by some of the photographers discussed in the biographical essays, this section includes photographs by other notable project participants—John Collier, Arnold Eagle, Morris Engel, Elliott Erwitt, and Lisette Model.

The exhibition checklist includes the unabridged original captions as well as the negative numbers and instructions for ordering prints from the University of Louisville Photographic Archives. A selected bibliography of collections, books, and articles pertaining to the Standard Oil Company project is included for those who wish to delve further into the subject. My master's thesis, listed in the bibliography, is a source of more detailed information on the Standard Oil Company project.

At the time I began my research in 1979, it came as no great surprise to learn that most of the written records of the Jersey Standard project had long since been discarded. But while much of the written record was gone, the project had not been forgotten by those who had had a part in it. For freely sharing their knowledge and insights, I am very grateful to Standard Oil photographers Charlotte Brooks, Esther Bubley, Harold Corsini, Arnold Eagle, Russell Lee, Sol Libsohn, Gordon Parks, Martha Roberts, Edwin Rosskam, Louise Rosskam, Charles Rotkin, and Todd Webb; and to former Standard Oil Public Relations Department employees Anne Adams, Sally Forbes, Edward R. Sammis, and Edward Stanley. Unless otherwise indi-

cated, all quotations attributed to them are drawn from the interviews they granted me which are listed in the bibliography.

I am also indebted to James C. Anderson, David G. Horvath, Bill Carner, Barbara Crawford, and Mark Dickson of the University of Louisville Photographic Archives, the repository for the Roy E. Stryker and the Standard Oil Company photograph collections; Brian Vachon and François Vachon; Phyllis Stryker Wilson; Mrs. Carl Maas; Cornell Capa, Ann Doherty, Anna Winand, and the staff of the International Center of Photography; Professor F. Jack Hurley, Memphis State University; Professor Bernard M. Mergen, George Washington University; Professor Bennett H. Wall, University of Georgia; Leonard Fleischer, Elton Robinson, Princetta Johnson, and the late Robert E. Kingsley, Public Affairs Department, Exxon Corporation; and Eric Anderson, Jim Bonar, Rick Frederick, Colleen Holwerk, David Holwerk, Mary Horvath, Dottie Lewis, Dan Pearlman, David Rosen, and David Rueve.

S.W.P.

Introduction

by Steven W. Plattner

IN 1962 Edward Steichen, renowned photographer and director of photography at the Museum of Modern Art, unveiled an exhibition of nearly two hundred photographs of Depression-era America. Entitled "The Bitter Years," the exhibition consisted of photographs taken between 1935 and 1942 by a small band of photographers who had worked under the direction of Roy Emerson Stryker, chief of the "historical section" of a relatively obscure New Deal agency, the Farm Security Administration (FSA). Among the photographers represented in the exhibition were Walker Evans, Dorothea Lange, Russell Lee, John Vachon, Jack Delano, Ben Shahn, and Marion Post Wolcott. "The Bitter Years" set off a wave of much deserved veneration for their photographs; in the years since, scores of books, articles, and exhibitions examining the work of these photographers have appeared.

While the story of the FSA historical section has been told in detail, historians and curators have seldom made more than passing mention of another equally remarkable documentary photography project directed by Roy Stryker and patterned, to some degree, on the FSA project. This oversight has resulted in an incomplete appraisal of the contributions made to documentary photography by Roy Stryker and the photographers who participated in the Standard Oil Company (New Jersey) photographic project.

Between 1943 and 1950, Standard Oil sponsored the largest photographic documentation project ever undertaken in America by anyone other than the federal government. The photographers of Standard Oil recorded "how oil seeped into every joint" of an increasingly technological nation. Several of America's finest photographers participated in the Standard Oil project, including Berenice Abbott, Charlotte Brooks, Esther Bubley, Harold Corsini, Arnold Eagle, Morris Engel, Elliott Erwitt, Sol Libsohn, Lisette Model, Martha McMillan Roberts, Louise Rosskam, Charles Rotkin, Todd Webb, and former FSA photographers John Collier, Russell Lee, Gordon Parks, Edwin Rosskam, and John Vachon. Besides depicting nearly every conceivable detail of their sponsor's operations, these photographers freely documented topics as tenuously related to the oil industry as life in a small Montana town, a public prayer meeting on VE Day, the nomadic existence of truck drivers, women at work in defense plants, and a North Dakota gravedigger carving away at the frozen earth. Considered collectively, the 67,000 photographs taken for the Standard Oil project form a vivid pictorial record of home front America during and after World War II.

The circumstances behind the founding of the Standard Oil Company photographic project require explanation. Large corporations, after all, are not in the habit of spending hundreds of thousands of their shareholders' dollars on documentary photography projects. The Standard Oil project was conceived as one small part of a massive public relations effort intended to improve the company's image.

At the time of the Japanese attack on Pearl Harbor, Standard Oil occupied an enviable position among American businesses as the world's leading producer and distributor of petroleum products. Its operations spanned the globe. Its American work force exceeded 50,000 men and women while its total revenues, awesome even when measured against present-day standards, amounted to more than $1 billion.

Much to Standard Oil's displeasure, Assistant Attorney General Thurman W. Arnold, head of the Antitrust Division of the Department of Justice, launched an aggressive investigation of cartel arrangements between foreign and American businesses in early 1942. The most publicized of these probes revealed that in 1929 Standard Oil Company had signed an accord with the German petrochemical firm I. G. Farbenindustrie which, Arnold contended, effectively prohibited Standard from pursuing the development of a process for synthetic rubber. In return, Farben had agreed not to compete with Jersey Standard as a producer or marketer of petroleum products on American soil. The Japanese invasion of the East Indies and Malaya, which together had furnished 90 percent of America's prewar crude rubber, created a severe shortage of this substance just as it became vital to the war effort.

Appearing before the Senate Committee on National Defense on 26 March 1942, Arnold alleged that Jersey Standard's "'. . . cartel arrangements with Germany [were] the principal cause of the shortage of synthetic rubber.'"[1] According to *Newsweek*'s account of the proceedings;

The Senators sat grim and visibly shocked as they listened to these revelations. Afterward, Sen. Harry S. Truman, the committee's usually placid chairman, exclaimed to a reporter: "I think this approaches treason."[2]

Generally, the press coverage of the hearings which followed painted an unattractive picture of Standard Oil. On its editorial page of 2 April 1942, the *New York Times* voiced agreement with Arnold's argument that patent arrangements between American and foreign corporations should be approved by the federal government in the interest of national security. The editorial concluded, however, that Arnold's "charges that Standard Oil is responsible for the shortage of synthetic rubber simply evaporate. It is apparent that he did not have the facts." On 7 April 1942, the final day of the rubber hearings, Secretary of Commerce Jesse Jones testified that he and President Roosevelt had agreed not to engage the government in a massive synthetic rubber program before America's entry into the war due to the great expense of such a project.[3] This admission of guilt on the federal government's part, however, did little to offset the public's hostile feelings toward Standard Oil.

Initially, Jersey Standard's officers were shocked by Arnold's charge. The paradox of the situation, as explained by Edward Sammis, editor of the company shareholder magazine *The Lamp*, was that "While some of the directors' sons were being killed in action in the South Pacific, the directors were being accused of being traitors." Groping for ways to improve its public reputation, Standard Oil retained Earl Newsom, a former schoolteacher who in 1935 had founded one of Madison Avenue's most distinguished public relations firms.

Newsom recognized that a reasonably concrete measurement of Standard Oil's public image was needed. He asked pollster Elmo Roper to survey the public's opinion of Standard Oil in particular and the oil industry in gen-

1. Henrietta M. Larson, Evelyn K. Knowlton, and Charles S. Popple, *New Horizons, 1927–1950: History of Standard Oil Company (New Jersey)*, p. 819.
2. "Blast at Standard Winds Up Antitrust Actions for Duration," *Newsweek*, 6 April 1942, p. 46.
3. Larson, Knowlton, and Popple, *New Horizons*, p. 451.

eral. When asked "Why are your feelings not so friendly toward Standard Oil Company of New Jersey?" nearly 60 percent of the respondents cited some aspect of the company's dealings with I. G. Farben. The findings brought out in the poll stunned the company. Those persons questioned felt that the oil industry was essentially corrupt and that Jersey Standard was particularly tainted. Furthermore, the survey revealed that in the public mind the Standard Oil Companies of New Jersey, California, Kentucky, Indiana, and Ohio were still one immense trust when, in fact, they had been separated by the Supreme Court thirty-one years earlier.

Roper's survey revealed one other significant finding. Certain "thought leaders," Roper found, were proportionately more critical of Standard Oil than other segments of the public. Influential, "white-collar" Americans—particularly professionals, academics, and even business executives—possessed the most hostile opinions of Standard Oil. George Freyermuth, who would become the manager of Jersey Standard's first Public Relations Department in 1943, has described the importance of the "opinion leader" concept and its implications for Standard Oil in the 1940's:

Roper's early surveys showed clearly that the erudite, the academic, the educated people were able to make judgments, and the more they knew about things in general, the less they liked the company and the more critical they were of the company. And, of course, a theory then, and I think one that's fairly well-supported, is that public opinion is established by opinion leaders . . . At least the concept of a lot of public relations people has been that you can't talk to 100 million or 200 million people, but there are 20,000 people that are the ones you really want to get to . . . In general, opinion leaders of that time were supposed to be among the educated, the artistic and that kind of sophisticate.[4]

Carl Maas, an art consultant retained by the company in 1944, recalled that Roper's survey also contended that the "thought leaders" were also "more conscious of art than the public as a whole."[5]

With the realization that these influential, well-educated "thought leaders" tended to be highly critical of the company while they were also "conscious of art," Standard Oil began to select the visual media for use in its public relations efforts. Although the notion of using the visual arts in corporate public relations programs was a novel one to Standard Oil, industrial use of the visual arts was hardly a new phenomenon in 1943. As early as the late 1920's, artists had seen their works published as advertising illustrations. Pierce Arrow, Steinway & Sons, and numerous others had incorporated the work of fine painters in their advertisements. During the 1930's, the Dole Pineapple Company had flown the highly independent painter Georgia O'Keeffe to Hawaii to portray its product.[6] In 1939, De Beers Diamonds, Ltd., commissioned several artists, including Aristide Maillol and André Derain, to create drawings which it published in its advertisements.

In addition to the use of visual arts in advertising, government sponsorship of artists during the 1930's, fostered by social and political impulses, provided corporations like Standard Oil with an example of the practical usefulness of artists.[7] As the federal government relinquished its role as sponsor to down-and-out artists with America's entry into World War II, private enterprise rapidly assumed its part in applying the talents of artists to its public relations needs.

4. Interview with George Freyermuth by Bennett Wall, San Francisco, 26 April 1976.
5. Carl Maas, "Jersey and the Arts" (manuscript, 29 June 1972), p. 2.
6. Mitchell Kahan, ed., *Art Inc.: American Paintings from Corporate Collections*, p. 13.
7. Russell Lynes, *The Tastemakers*, pp. 291–292.

Public relations, not advertising, was at the heart of Standard Oil's employment of photographers, painters, and filmmakers during the 1940's. What really distinguished Standard Oil's use of visual artists from that of other companies was its emphasis on creating a documentary record of its operations in America. Cooperating with the Associated American Artists, in 1944 Jersey Standard commissioned sixteen painters to record the major role played by the oil industry in the war effort. The participants included Adolph Dehn, Frederic Taubes, Joe Jones, and Thomas Hart Benton. Although their work was praised widely by viewers in museums and university art galleries, it did not prove to be particularly popular with Standard Oil's directors. Some months later, when several of the paintings were offered to the directors, Edward Sammis was told by one influential member of the board to "bring me a good, honest photograph!"

Edward Stanley, a close friend of Roy Emerson Stryker, proposed in mid-1943 that Standard Oil create a documentary photographic record of the oil industry. Stanley's hypothesis was both simple and logical: A documentary photography project sponsored by Standard Oil and fashioned after Stryker's Farm Security Administration historical section could, conceivably, serve the company's public relations needs as effectively as the FSA had publicized the problems of the rural poor during the 1930's and 1940's. As the executive photograph editor for the Associated Press during the late 1930's, Stanley was in a good position to understand the potential merits of such an undertaking. He greatly admired the work of the FSA historical section photographers. Assessing the overall effect of the FSA photographs, Stanley has said, "More than anything else, I suppose, Roy Stryker's photographs that were moved out on the Associated Press made the general public aware of what the general situation was [during the Depression]."[8]

Before he joined Earl Newsom and Company, Stanley had worked in the Domestic Services Branch of the Office of War Information (OWI), a "curiously difficult place" to which Roy Stryker and his dwindling staff had been transferred in 1942. In all likelihood, Stanley was well aware of Stryker's disdain for the OWI's approach to photography. As Stanley has noted,

With the war, the whole New Deal turned around. There wasn't the same amount of money [for projects such as the FSA historical section]. There wasn't the same amount of interest in pictures of the dreadful dustbowl.

Instead of photographing the "ill-fed, ill-clad, ill-housed" one-third of the American people described by Franklin D. Roosevelt in his second inaugural address, Stryker and his photographers soon found themselves depicting "shipyards, steel mills, aircraft plants, oil refineries, and always the happy American worker," making pictures which "were measured only by their propaganda value"[9] Although Stryker fought hard for honest, authentic documentation of the vital roles factory workers, farmers, and others played on the home front, his superiors in the OWI did not share his editorial preferences.

Stanley asked Roy Stryker to consider directing a project to document Standard Oil's operations. At first, Stryker politely declined his friend's offer. Later, he explained why Stanley's proposal had puzzled him. Stryker, a former cowboy, World War I infantryman, miner, and economics instructor at

8. This and all subsequent quotes not otherwise identified are from my own interviews with Standard Oil project photographers and Public Relations Department employees. See the bibliography for a complete listing of the interviews.
9. John Vachon, "Tribute to a Man, an Era, an Art," *Harper's Magazine*, September 1973, p. 99.

nicating facts about the complex that is the modern industrial world."[20] A single, symbolic photograph devoid of human beings such as Stieglitz's "The Hand of Man," for Stryker, could never come close to imparting the wealth of significant facts about American industry.

What was required instead, wrote Stryker, were photographers possessing "insatiable curiosity, the kind that can get to the core of an assignment, the kind that can comprehend what a truck driver, or a farmer, or a driller, or a housewife thinks and feels and translate those thoughts and feelings into pictures that can be similarly comprehended by anyone."[21] While he believed that Standard Oil's operations were "more technical than anything we had touched [at FSA]," Stryker realized that the company's work "was still done by human beings."[22] He insisted that

industry, from top to bottom, consists of people whose efforts and skills are the basis of productivity. [The Standard Oil photographers] feel that people and not the machines they work with are what is important in our industrial civilization.[23]

The desire to photograph the drillers, seismologists, surveyors, and chemists who produced the oil consumed by truck drivers, farmers, and housewives was as compatible with Standard Oil's public relations requirements as it was with Stryker's principal concern with creating a lasting cultural document. The company's favorable inclination toward a human-oriented photographic approach was rooted in the exigencies of its public relations difficulties. Ever mindful of the findings of Elmo Roper's 1942 poll, the Public Relations Department felt that photographs focusing on "the human part" of the company's work, particularly the everyday lives of its workers and their families, might foster the impression in the public mind that Standard Oil was composed of "human beings like everybody else."[24] In demonstrating, through photographs, the importance of the tasks its employees performed and the value of the products it manufactured, Standard Oil sought to project a public image as a company that "is a good citizen . . . that always works in the public interest."[25]

Stryker's direction of "informed photographers" at Standard Oil took a wide variety of forms. The experiences shared by several of his former photographers indicate that, above all else, Stryker treated them as individuals. As Todd Webb says, Stryker was a "psychologist of sorts . . . [who] . . . handled different people different ways."

As a former teacher and New York City settlement house worker, the garrulous Stryker was especially effective at instilling in the photographers a sense of the historical significance of their work. Stryker, says Sol Libsohn, wanted

to produce a document meaning something that would remain a valid history of what was happening in the U.S. He was a collector . . . a collector of Americana—not that he really knew a lot about photographs—but he had a great deal of feeling for wanting to know what was happening and why.

"One of the great things about Stryker," adds Edward Sammis, "was how he used to brief his photographers." According to Sammis, Stryker often reminded the photographers,

20. Stryker, "Documentary Photography in Industry," p. 324.
21. Ibid.
22. Interview with Stryker by Doherty et al., p. 54.
23. Roy Stryker, untitled manuscript (n.d.), p. 1, Stryker Collection.
24. Interview with George Freyermuth by Bennett Wall, New York City, 18 December 1975, p. 8.
25. Larson, Knowlton, and Popple, *New Horizons*, p. 630.

*out and take pictures that mean something. They should strive for photo-
graphs which will show the modern industrialist things about his business
that he never knew existed.*[17]

While not "sufficient qualifications" in themselves, technical competence and
artistic ability were also prerequisites in Stryker's hiring of photographers.
The photographers, whose work became the property of the company, were
paid at the rather handsome rate of $150 per week plus expenses. Working on
a contractual, assignment-by-assignment basis also allowed them to accept
occasional assignments from magazines like *Fortune* as well as from other
clients. Normally, four, five, or six photographers were in the field at any
given moment during the six-and-one-half-year life of the project.

In a rather immodest article on the Jersey Standard project published in
U.S. Camera Annual 1947, Stryker expounded further on the type of pho-
tographer he considered best suited for documenting the production and uses
of oil. He boldly declared that the typical industrial photograph made prior to
the Standard Oil project tended to be little more than a "simple little cliché."
Characterizing the work of earlier American commercial and industrial pho-
tographers as "uninspired but essentially honest," Stryker observed that the
industrial photograph had generally "consisted of a panoramic view of the
interior or exterior of an entire factory." Without citing specific examples,
he asserted that

*Late in the '20's art with a self-conscious capital "A" crept into industrial
photography. The photographer wasn't exactly told to make a silk purse out
of a sow's ear, but he was expected to try. As a consequence the industrial
scene became a series of jewel-like structures gleaming against a smoke-
less, red-filtered sky.*[18]

Stryker's comments were probably intended as a criticism of the work of
"Photo-Secessionist" photographers such as Alfred Stieglitz and Alfred Lang-
don Coburn, or perhaps of the industrial photographs of subjects such as
Ford Motor Company's River Rouge plant made in 1927 by Precisionist
painter and photographer Charles Sheeler. In 1902, Stieglitz had made "The
Hand of Man," a metaphorical, soft-focus image of a steam locomotive in a
gritty, urban setting. Coburn's equally formal pictures of the smoky atmo-
sphere of Pittsburgh, taken in 1910, are conceivably another example of the
type of approach to industry which Stryker preferred to subordinate to in-
formed "photo-reporting" by the photographers of Standard Oil.

What made Stryker's Standard Oil project distinctive from past efforts in
industrial photography was its insistence on a comprehensive and realistic
documentation of virtually every aspect of oil production and consumption. In
essence, Standard Oil's photographers were

*to tell the story of oil from the jog on the seismographer's chart to the car,
home, or business of the user—and to tell it always with the accent of the
man on the job: from scientist to roughneck, from pipeline rider to service
station operator.*[19]

In the hands of Stryker's Jersey Standard photographers, the camera was not
meant to be a "means of precious art expression, but a method of commu-

17. Roy Stryker, untitled manuscript (n.d.), p. 7, Stryker Collection.
18. Roy Stryker, "Documentary Photography in Industry," in *U.S. Camera Annual 1947*, ed.
 Tom Maloney, p. 320.
19. Carl Maas, untitled manuscript (1949), p. 1, Stryker Collection.

he could not have realized it at the time, "never again would the government engage in documentary photography on such a scale or with such skill."[13]

Before he arrived in New York, Stryker had already begun to envision the scope and direction of Standard Oil's new photographic venture. More often than not, at Standard Oil Stryker retained the methods and concepts he had developed in Washington as a director of photographers with the Farm Security Administration. As had been the case at FSA, Stryker remained a *director* of photographers rather than a photographer himself. In the words of Gordon Parks, Stryker "couldn't even load a camera." Whether at FSA or Standard Oil, Stryker's detachment from the practice of photography, according to historian F. Jack Hurley, allowed him to be "completely free to guide and motivate without becoming caught up in either the mechanics of photography or any other stylistic approach."[14]

Because very little evidence, such as correspondence and company memos, has survived, it is difficult to reconstruct Stryker's earliest days at Standard Oil. Harold Corsini, one of the major project photographers closest to Stryker at Jersey Standard, recalled that his boss seldom shared any specific objectives he may have had for the project. According to Corsini, "Stryker never took me aside and was never very intimate about what his hopes for it were." Writing to Earl Newsom shortly before he was hired by Standard Oil, Stryker defined documentary photography as "the recording and interpretation of whole environments in extensive picture series," which when accumulated, would result in a broad, inclusive file of photographs.[15] To be effective, Stryker felt that the file must consist of at least 25,000 photographs. Actually, the number of images made by the nearly thirty photographers involved in the Standard Oil photographic project greatly exceeded the 25,000 minimum set by Stryker. By 1950, the total cost of the project had surpassed $1 million, and the photographers had produced 67,000 black and white images and at least 1,000 color transparencies.

To create a file of 25,000 or more photographs, Stryker estimated he would require the services of four full-time photographers. Not just any photographer would do, however. Stryker preferred the "informed photographer" over the photographic artist. Still placing faith in his credo from FSA days, Stryker maintained that "Documentary is an approach, not a technique . . ." He insisted that his Standard Oil photographers "know enough about the subject matter to find its significance in itself and in relation to its surroundings, its time, and its function."[16] In an unpublished manuscript Stryker offered a definition of the type of photographer he wished to hire at Standard Oil:

To make significant and valuable industrial photographs, [the photographers] have to be alert and responsive to the world about them. Their education should never stop, but should go ahead, step by step, day by day. They should know something about economics, history, political science, philosophy, and sociology. They have to be able to conduct research, gather and correlate factual information, and think things through. Then they can go

13. F. Jack Hurley, *Portrait of a Decade*, p. 173. Of the books written about Roy Stryker and the FSA historical section, this is by far the most informative and scholarly work available.
14. Ibid., p. 55.
15. Roy Stryker, memorandum to Earl Newsom, August 1943, p. 3, Roy Stryker Collection, Photographic Archives, University of Louisville (referred to hereafter as Stryker Collection).
16. Stryker, "Documentary Photography," p. 1368.

Columbia University, had wondered, "What would Standard Oil want from me, a New Dealer, the son of a Populist?"[10] An article published in *Minicam Photography* in 1947 provided more information on the source of Stryker's discomfort at the thought of accepting a position with Standard Oil Company. Stryker explained to the authors of the article that his father had been "an extremist" who was "always trying new things and he tried them harder than anybody else." At one point during Stryker's youth on the Kansas plains, his father "got religion from a circuit-riding preacher." As a consequence, Stryker recalled,

We all had to get down on our knees in the evening and pray good and loud and nobody prayed louder than he did—especially at the end of one day when he had been out stumping for Populism. He started out all right, but all at once his convictions got hold of him, and at the top of his voice he prayed: "Please God, damn the bankers of Wall Street, damn the railroads, and double damn the Standard Oil Company!"[11]

This confession, however, did not deter Stanley from his effort to hire Stryker.

The Populist's son, Stanley recalls, "had to think quite a bit about whether he would work for a big corporation with a disputed reputation since Ida Tarbell." He asked Stryker to consider the many important and fascinating opportunities he would have in documenting the petroleum industry. Stanley remembers saying,

Roy, I don't have to persuade you. There are several things you can do. First of all, you can show the genuine face of an industry insofar as its operations are concerned . . . you can show who these people are, what they look like . . . You have an opportunity to document one of the great industries of the world, maybe the greatest in some respects. It's got everything. It's got science, it's got geology, it's got chemistry, and the technical operations—the ships and the roughnecks out looking for oil. It's a very dramatic thing, all pulled together. I think you should have a look at it and make a history of it if you want to. No one will hinder you.

Two additional factors may have weighed heavily in Stryker's decision to abandon his dismal situation in the federal government. It is worth noting that in high school, Roy Stryker had excelled in chemistry and the natural sciences before attending the Colorado School of Mines for one year. His training and aptitude in the sciences may have helped him appreciate the value and beauty of technical processes. And, before he moved to Standard Oil's Rockefeller Center offices, the company paid Stryker to take a "quick trip" to see for himself whether "running oil" might indeed be an exciting business to document. In a 1972 interview, Stryker described the experience:

I saw those drillers—[they were] fascinating people, [and it was] a fascinating spot. I saw the oil coming up, down in the bayous of Louisiana. I saw that and I said, "By God, something can be made of it. And oil is damned important" . . . I was sure we could do something with it.[12]

On 4 October 1943, Roy Stryker, described by Harold Corsini as a Depression-era "apostle of the downtrodden," left the government to become a full-time, well-paid employee of Standard Oil Company (New Jersey). Although

10. "A Portrait of Oil—Unretouched," *Fortune*, September 1948, p. 102.
11. Jhan and June Robbins, "The Man behind the Man behind the Lens," *Minicam Photography*, November 1947, p. 146.
12. Interview with Roy Stryker by Robert J. Doherty, F. Jack Hurley, Jay M. Kloner, and Carl G. Ryant, Louisville, 14 April 1972, p. 53.

You're not just photographing for Standard Oil. You're photographing America. You're recording history. Everything is in flux. You will see things that won't be around again.

Citing Esther Bubley's extensive coverage of the oil town of Tomball, Texas, in 1945 as an example of Stryker's ability to stimulate photographers, Sammis recalls Stryker telling Bubley to

Stay six weeks if you have to. Do your oil stuff, get the feel of it. You're doing Americana. Just take everything in sight and shoot it. Don't worry about the expense.

The 600 photographs resulting from her assignment suggest that Bubley took Stryker at his word.

Generally, Stryker's directives to Standard Oil photographers decreased as they gained experience and gradually earned his trust. Whenever he felt it necessary, Stryker sent photographers into the field with so-called "shooting scripts." Esther Bubley insists that these were nothing more than "big, broad, general outlines." The "scripts," she says,

were very general. They weren't shooting scripts for Texas or something else. They covered everything. First, the land. What does it look like? What do the people look like? What sort of farming is there, if any? What sort of industry is there, if any? They could have been applied to any place.

Bubley's description of the vague nature of Stryker's outlines echoes that of Harold Corsini.

Photographing general things like "What people looked like" were just de rigeur. We always took pictures of interesting hands, interesting faces, what the people looked like and interesting machinery. It was pretty cut and dried . . . There wasn't any way to write a script.

Todd Webb was never given a "shooting script" at Standard Oil. Webb, who was a highly experienced photographer at the time he joined the project, recalls:

If there was any shooting script, it was your own personal shooting script. There was never one given to you by Roy. He might talk to you before you went out on a trip and say, "Now I hope that you will look for things that will be useful for the file, things that people will be interested in." But he would never be very specific about it, not to me anyway.

While Stryker routinely suggested specific places or subjects he wished to see documented, he refrained, for the most part, from interfering with the photographers' interpretive and aesthetic freedom. Although he might tell a photographer "what to look for," he refused to dictate what the photographer was expected to depict. He ensured that the photographers were left unfettered in terms of interpretation and stylistic approaches, so that they were able to portray their subjects in an honest and realistic manner. For Stryker to have prescribed a particular interpretive approach would have robbed the photographers' work of its spontaneity and credibility as much as it would have compromised the project's integrity.

The definition of legitimate subject matter for documentation by the project photographers was extraordinarily broad. While the photographers were usually sent into the field to portray a particular oil-related subject or place, Stryker also exhorted them to photograph nearly anything else that caught their eyes, no matter how tangentially related to the petroleum industry. As Esther Bubley has put it,

Any way you could connect something to oil—that for Roy was a good enough excuse to photograph it. You could photograph anything having to do with oil.

Russell Lee, the former FSA photographer who also worked for Stryker at Standard Oil, has said that "Anything that happened to use grease was enough justification" to be photographed and added to the project's files. These definitions of the project's extremely inclusive coverage help explain why Lee chose to photograph a truck driver napping in his cab in Vernon, Texas (Plate 101), and why Harold Corsini elected to point his handheld Rollei at refinery workmen's overalls drying on a clothesline (Plate 124).

The geographical scope of the Standard Oil Company photographic file was somewhat narrower than that of the FSA collection. At FSA, Stryker had assigned photographers to document the diversity of rural and small-town America, from Maine to California, from Minnesota to Texas. But at Standard Oil, the photographic project's territorial scope was determined primarily by the nature of the company's functions as a producer and marketer of petroleum products. As a result, most of the photographs made for Standard Oil were taken in the company's largest oil-producing, -refining, and -consuming states: Texas, Louisiana, Oklahoma, Montana, Wyoming, New York, New Jersey, Pennsylvania, and the New England region were photographed much more extensively than the remaining states. There are no photographs of California in the Jersey Standard file due to the simple fact that it came under the jurisdiction of the Standard Oil Company of California. Several thousand fine photographs were also made by Standard Oil project photographers in Venezuela, Saudi Arabia, Colombia, Peru, France, Belgium, and a number of other nations.

In order to be of some use to Jersey Standard's public relations program, the images produced by the project photographers needed to be disseminated through publication and exhibition channels. During the first six months of the project, the responsibility for distributing photographs rested solely with Stryker and his small office staff. When it was found that the project photographs were not being disseminated to the extent desired by the company's management, the entire Public Relations Department was given responsibility for making them accessible to publishers, editors, and others. This shift in Stryker's responsibilities was very important; it suggests that he was far more interested in compiling a historically valuable pictorial record of oil than he was in how Standard Oil chose to use its photographs toward solving its public relations problems. Harold Corsini agrees that Stryker considered himself to be a compiler of photographs of American life more than a public relations propagandist:

I was constantly badgering him, asking him how the pictures were being used. "Where do you use the damned things? Give me some hint as to what the current usage of the pictures is." . . . He wasn't very good at it. He was always saying, "Well, they go into a file." And of course to him, the fact that there was a file was reason enough. He wasn't interested in pushing the pictures. . . . He thought that the usage of the pictures, finally, how the company used them . . . was up to the [company's] writers and the so-called "p.r. people."

In *U.S. Camera Annual 1947,* Stryker wrote, "It is obviously unsound to build up a file of pictures that flash like meteors across the news pages of the country and go into perpetual limbo."[26] This comment actually comes much closer to reflecting the Public Relations Department's philosophy of pho-

26. Stryker, "Documentary Photography in Industry," p. 325.

tographic distribution than it does Stryker's. The essential idea, according to George Freyermuth, Stryker's boss at Standard Oil,

was that we wanted newspapers and magazines and others that wanted pictures to illustrate anything to come to us as a source for them, and over the course of time, to therefore identify Standard Oil of New Jersey as doing a whole range of things: taking care of little babies and promoting medical centers or being interested in what was going on in the playgrounds. We wanted them to know that we were people too and it had that effect.[27]

Apparently, the company's desire to see publishers, editors, writers, and others utilize its growing picture files, was realized. After going to work as the project's photographic librarian in 1946, Sally Forbes "had as many as twenty people a day" make use of the picture library. The library visitors, Forbes recalls, "were always surprised at how much wonderful stuff they could find, not just of precise oil subjects, but [of] related subjects."

Much of the interest shown in Jersey Standard's photographs during the 1940's can be attributed to two inducements. First, the company published *Photo Memo*, a periodic offering of representative images and "picture stories" done by the project photographers. This handsome publication carried the negative numbers, captions, and instructions for ordering the photographs. But in all likelihood, the greatest enticement to picture users was the company's willingness to open its photographic project files to virtually anyone possessing any reasonable purpose. There was no charge whatsoever for the prints; the only requirement was that a credit line reading "Standard Oil Company (N.J.) photo by ____" be given for all photographs published or exhibited. In 1949 alone, nearly 50,000 prints were distributed by Standard Oil.[28] Project photographs graced the pages of nationally circulated magazines including *Fortune, Time, Life, Vogue,* and the *Saturday Evening Post.* By 1949, project photographs had helped illustrate more than one hundred books, especially school texts. The photographs were also exhibited in several of America's finest museums, including the Museum of Modern Art, George Eastman House, and Chicago's Museum of Science and Industry.[29]

Working as a photographer for Roy Stryker at Standard Oil could be quite lucrative. During the 1940's, the availability of the kind of nearly unrestricted photographic work practiced by Stryker's FSA photographers had been lost to the vicissitudes of war and budget cuts. As Charlotte Brooks said, "At the time, the idea of being able to be paid to photograph practically anything you wanted to photograph, and to be paid what I considered to be a fantastic amount of money . . . was an incredible opportunity." At Standard Oil, says Louise Rosskam,

None of the photographers were used to having any money to speak of. And all of a sudden, Standard Oil paid these fantastic wages and then besides, they made you submit an expense account for everything. We didn't know what an expense account was, and we used to put down our gas and our oil and costs like that. But then, Roy sent it back and said, "Where's your cleaning bill? You must have had a cleaning bill. And what about your meals?"

Edwin and Louise Rosskam were compensated so well for their efforts at Standard Oil that they lived on their project earnings for three years afterward.

Besides providing immediate economic benefits, participating in the Standard Oil project also enabled several of the photographers to establish

27. Interview with George Freyermuth by Bennett Wall, San Francisco, 26 April 1976, p. 12.
28. Carl Maas, "Photographic Section, Public Relations Department, Standard Oil Company (N.J.)" (manuscript, 1949), p. 9, Stryker Collection.
29. Ibid.

their careers and reputations in the highly competitive photographic world. John Vachon and Charlotte Brooks soon earned staff photographer positions with *Look*. Esther Bubley and Gordon Parks were hired by *Life*. Charles Rotkin, Russell Lee, Harold Corsini, Sol Libsohn, and John Collier were offered occasional assignments by *Fortune*, among numerous other magazines of the day. The "picture story" style which Stryker advocated at Standard Oil prepared many of the photographers for their later careers. The "picture story" approach, recalls Gordon Parks, "was good training for us because later on, when I went to *Life Magazine*, I certainly knew the approach to photographing a city or whatever I was photographing."

Photographing for Standard Oil offered the photographers the chance to explore vast stretches of America. Whether traveling along inland rivers, or documenting distant refineries, Louise Rosskam experienced "a real revelation—the feel of America . . . because we hadn't ever had the opportunity to get around the way we did and to get to know so many different kinds of people," including seismologists, engineers, surveyors, towboat captains, and refinery porters.

While the work of the FSA photographers had often emphasized the socioeconomic hardships faced by poor rural Americans, Stryker's Standard Oil group generally documented the thriving producers and consumers of oil. The intention of the Standard Oil project, says Harold Corsini, "was to explain that Standard Oil was a nice company and one that lots of people earned their livings from." This was quite a contrast to the FSA project, whose underlying intention during its first two years (1935–1937) had been to elucidate, through photographs, the need for federal programs to aid the destitute. Dorothea Lange's classic "Migrant Mother" and Arthur Rothstein's "Dust Storm, Cimarron County, Oklahoma" (both from 1936) are both outstanding examples of work from the first two years of the FSA project. By 1937, however, the scope of the FSA project was enlarged considerably. Influenced by his friend Robert Lynd, coauthor of the sociological study *Middletown*, Stryker encouraged the FSA photographers to document the proud, determined small towns of America. As a result, the FSA files began to offer a more balanced view of the country during the Depression years— not just destitute farmers, but small towns "getting by," and occasionally even large urban centers like New York, Chicago, or Cincinnati.

Due largely to America's war-induced emergence from the Depression, the Standard Oil photographers seldom found themselves in a position to record subjects as emotional as "the horror of the Depression or what was happening to our farms and farmers." The company-sponsored photographs, according to Harold Corsini,

didn't have the emotional impact that the FSA project had—the survival, the dying . . . We were in a rich company that was making money off of everyone. The photographic situations were not that dramatic.

Inevitably, the positive outlook presented by the Jersey Standard photographs reflected the nature of the prosperous portion of society documented by the project. Although no one at Standard Oil ever told Edwin Rosskam "what to shoot or what not to shoot," he lived in "an atmosphere" which shaped the content of his work. As a company photographer, Rosskam recorded the everyday lives of

oil people [who] really did live under excellent conditions. So, the environment we lived in was a middle-class environment, even the roughnecks on the rigs. They were the most highly paid people around . . . so you didn't have the impulse to photograph the broken-down, the tragic . . . things didn't look the way they looked at the time of Farm Security.

Finding the company's individualistic roughnecks and drillers to be "tough and footloose and foulmouthed and picturesque," Edwin Rosskam considered them "more representative of the technological America that was being born in the '40's than the poverty-stricken farmers pictured by FSA."[30] While he readily concedes that the "composite image of so much energy and prosperity is bound to be less emotionally involving than that of migrants and sharecroppers," Rosskam feels it is also significant.[31]

The company's receptivity to documentary photography served most of the project photographers quite well; working for Standard Oil provided them with the support, as well as the freedom, to make honest photographs. The photographers realized that the Standard Oil project was not meant as a forum for socially concerned photographers who wished to see their work used to help reform American society. Charlotte Brooks commented, "I wasn't working in the context of the other federal programs that Roy [Stryker] was involved in, so I wasn't looking for the hard, the poverty, the driving kind of statement." Todd Webb found the freedom to take an honest, if positive approach to the important role played by oil to be one of the Standard Oil project's most appealing assets. At Standard Oil, the photographers could show "America as it was."

I did all right at Standard Oil because I didn't always have to show the downtrodden. You could show the good things too . . . I think that Stryker was interested in America as it was, a good part of America. I don't think he was interested at all in the so-called "ashcan photography." He didn't insist that you show only the bad parts of America. He wasn't like that.

For Russell Lee, who witnessed firsthand many severe instances of poverty during the Depression years, the company project was a logical extension both of his work during the 1930's and of his training as a chemical engineer and industrial plant manager.

I liked to photograph industry because it was part of society. I didn't have to, I just liked to. Actually, toward the end of Farm Security they were building Shasta Dam. And after all, I was a plant manager once and worked in industry for about three or four years.

The Standard Oil photographers were intrigued by American society in its entirety, its positive qualities as well as its glaring failures. In their view, America's makers and consumers of petroleum were no less worthy of documentation than the sharecroppers and rural migrants whose lives the FSA photographers had portrayed so eloquently only one decade earlier.

Early in 1948, several directors of the Standard Oil Company gathered behind closed doors for a routine company budget session. Among matters on their agenda was the funding of the company's four-year-old documentary photography project directed by Roy Stryker. Although records of their discussions no longer exist, their verdict was made known in numerical terms. The directors concluded that the $220,000 which had flowed into Stryker's project coffers in 1947 should be reduced sharply in 1948 to $130,000.[32] Tightening the valve on the company's expenditures, the directors determined that

30. Edwin Rosskam, "The Standard Oil Document: A Neglected Resource" (manuscript, n.d.), p. 4, Stryker Collection.
31. Edwin Rosskam, "Witness to the '40's" (manuscript, n.d.), p. 5, Stryker Collection.
32. Evidence that the decision to reduce Stryker's project budget was made during a company budget meeting in 1948 is from "A Portrait of Oil—Unretouched," p. 102 (see note 10 above). The precise project budget figures for 1947 and 1948 are from the Standard Oil Company photographic project budget, 28 March 1950, Stryker Collection.

the photographic project files had grown to be adequate for the needs of the Public Relations Department and that further expansion should be limited to keeping the collection current. Although the directors were "properly proud of their unique photographic venture as a public service . . . they [were] not quite sure what the company [was] getting out of it, [and there were] times when they [wondered] if 'documentary' pictures of such subjects as tombstones in New Orleans or cockfights in Venezuela [were] not merely irrelevant."[33]

Somehow, despite the exhaustive public relations effort of which Stryker's photographic project was but one small part, the company's public image remained nearly as low in 1948 as it had been in 1942. "The curve on the [Elmo] Roper chart of Jersey Standard's place in the public sun," wrote *Fortune*, "has stayed low, but it is turning upward—slightly."[34] Presumably, the company's failure to improve its relations with the public was tied to its traditional image since the era of John D. Rockefeller, Sr.; in 1948, it seemed, Standard Oil still conjured up images of "Rockefeller, Trust, Big Business, Big Profits."[35] The contribution of Stryker's project to Standard Oil's slightly improved public relations picture was, *Fortune* noted, problematical.

Suppose 612 pictures did *appear last year [1947] in outside magazines and papers, in textbooks and encyclopedias. Who noticed the credit line and changed his mind about Standard Oil? The effects on the public are intangible and must be looked at from long range. It may be that students seeing the new pictures of the oil industry will think better of Standard Oil than did their fathers who were taught in terms of the Rockefeller trust and gushers. It may be that future historians will find valuable clues to twentieth-century mores in the photographs.[36]*

With no means available for measuring the degree to which the dissemination of Standard Oil photographs affected the company's public image, the directors apparently found it difficult to justify funding of Stryker's project at the high levels it had enjoyed in earlier years. Charles Rotkin summarized the essence of the problem:

A lot of the pictures were published showing what dandy people the oil companies were . . . You can bring in press clippings by the thousands of pictures courtesy of Standard Oil. But what that really meant, I don't know.

The public relations value of the photographic project, it seemed, was too subtle to be grasped. To a board of directors whose principal responsibility was manufacturing products, to men who ultimately gauged the worth of company activities in terms of profitability, company sponsorship of photographers was little more than a peripheral concern. Because it made no *discernible* contribution toward convincing the country's "thought leaders" to take a more benevolent view of Jersey Standard, the directors deemed Stryker's project expendable.

Soon after his budget trimming, Stryker laid the groundwork for his next documentary project, the Pittsburgh Photographic Library. Stryker became director of the library on 1 July 1950. For several years during the mid-1950's, Stryker directed a smaller documentary photography project focusing on the production of steel for the Jones and Laughlin Steel Corporation. After taking occasional consulting jobs from time to time during the

33. "A Portrait of Oil—Unretouched," p. 102.
34. Ibid.
35. Ibid.
36. Ibid.

1950's and 1960's, Stryker moved back to the rugged mountains of Colorado, where he died on 26 September 1975, at the age of eighty-two.

It matters little today that the Standard Oil project photographs did little to improve the company's public relations during the 1940's. What is more important, as Charles Rotkin points out, is that

. . . Roy Stryker was twenty-five or thirty years ahead of his time. Roy was an archivist. He didn't give a damn about a picture at the time it was made. He was interested in what it would mean twenty years later . . . He was saving pictures for a record of the past.

While the popular press busily covered the cataclysmic world events of the 1940's—the atomic bomb, the war, Nazi atrocities, America's rejuvenated economy, the Kinsey Report, the beginning of the Cold War—Roy Stryker directed the building of a photographic record of America on the home front, the day-by-day existence lived by ordinary Americans. Although the images which form the Standard Oil Company collection are not the stuff of which headlines were made, they remain significant documents of Americans working, playing, and interacting during one of this country's critical decades. More than thirty years after the end of the Jersey Standard project, this rich reservoir of photographs compiled under the aegis of Roy Stryker remains largely untapped. Only when we begin to consider the Standard Oil Company collection as an essential part of America's documentary legacy will these photographs be appreciated as images of an era.

ca. 1944. Photographer unknown.

John Vachon

John Vachon was one of the first photographers Roy Stryker hired at Standard Oil. Born in St. Paul, Minnesota, in 1914, Vachon graduated from Catholic University a few months before joining the FSA historical section staff in 1936—not as a photographer but as a file clerk–messenger. After several years spent filing and studying the pictures taken by FSA photographers such as Dorothea Lange, Walker Evans, and Russell Lee, Vachon began taking photographs on weekends. By 1941, Stryker recognized Vachon's growing talent and placed him on the payroll as a photographer.

Vachon followed Stryker from Washington to New York City in November 1943. After a quick trip spent photographing Standard Oil's Baltimore refinery, Vachon was dispatched to Venezuela, where he documented the lives of workers employed by Jersey Standard's affiliate, the Creole Petroleum Corporation. Among the most notable images made by Vachon in Venezuela were his "picture stories" of cockfights, school children, and offshore oil drilling on Lake Maracaibo.

Vachon's auspicious start at Standard Oil came to an abrupt halt when he was drafted into the Army in early 1944. He "spent the rest of the war making movies of pigeons in Central Park for the Signal Corps."[1] Vachon rejoined Standard Oil in the summer of 1947. After photographing examples of New Jersey's roadside architecture and popular culture (Plate 6), in October 1947 Vachon drove south to Virginia, West Virginia, and Maryland, where in 1942 he had spent his last six months as an FSA photographer. The photographs taken on this assignment reflect Vachon's approach to photography; along the way, he "photographed what pleased or astonished my eye, what I saw and wanted others to see . . ."[2] In West Virginia, Vachon made some of his finest project photographs, including an automobile junkyard near a steel mill (Plate 7), an opera house in Shepherdstown (Plate 11), and a row of smoky beehive coke ovens near Boomer (Plate 5). Fellow project photographer Charlotte Brooks, who, like Vachon, later worked as a staff photographer for *Look Magazine*, said that of all the Standard Oil photographers, Vachon had the most "identifiable style . . . a personal enough style that you could look at a photograph of his and say, 'That's a Vachon.'" Often, as in his photograph of West Virginia coke ovens, Vachon's work evoked what Brooks described as "a somber mood, not a sunlit mood at all."

In the dead of the winter of 1948, Vachon returned to the Dakotas to resume the coverage of the barren, sweeping plains he had begun as an FSA photographer nearly eight years earlier. Twenty-five years later, Vachon described his fascination with the Dakotas:

The Dakotas in winter were a revelation to me and became one of my favorite places in the world, like Paris, or the Italian Riviera, only different . . . I loved the wide open emptiness, the fact that there was nothing whatever to photograph.[3]

Vachon's stark photographs of a Ransom County wheat farm and a gravedigger going about his work (Plates 1, 4) are but two examples of the photographer's powerful attraction to the Dakotas.

Later in 1948, Vachon left Standard Oil to join the staff of *Look Magazine*. He received a Guggenheim Fellowship in 1973 to photograph the Dakotas. In 1975, he died of cancer in New York City.

1. Vachon, "Tribute to a Man, an Era, an Art," p. 99.
2. Ibid.
3. Ibid.

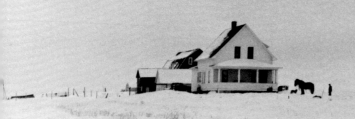

1. Ransom County, North Dakota, 1948

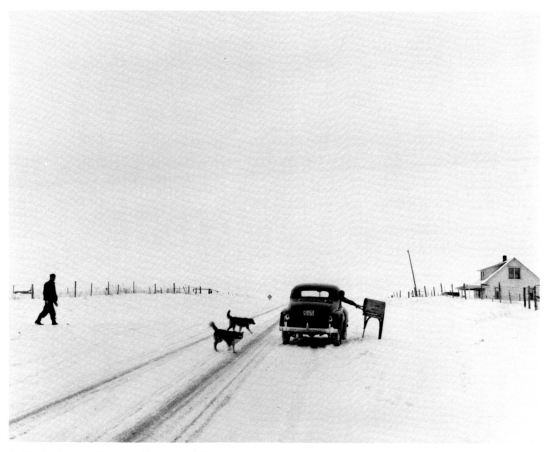

2. Mail delivery, Ransom County, 1948

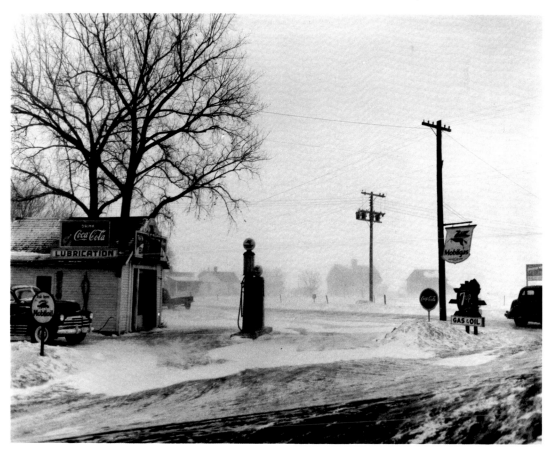

3. Wheaton, Minnesota, 1948

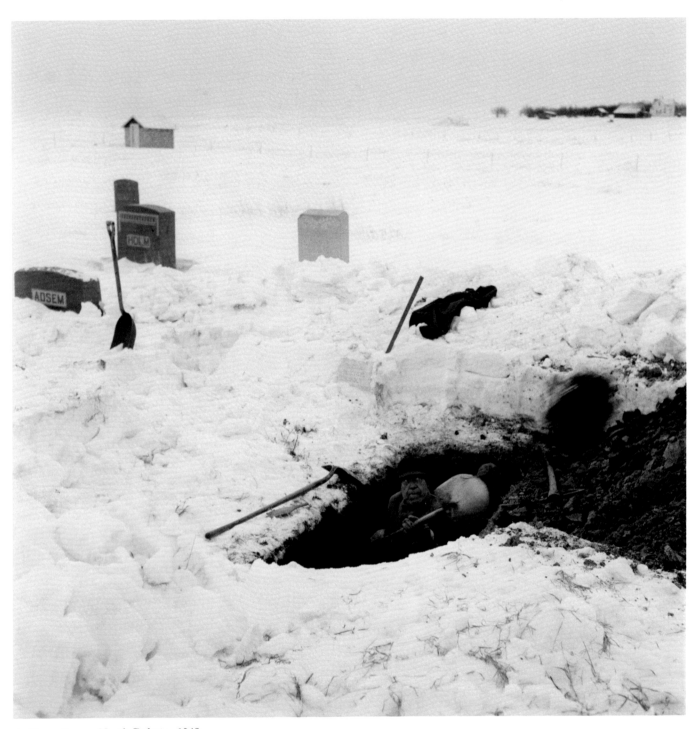

4. Gravedigger, North Dakota, 1948

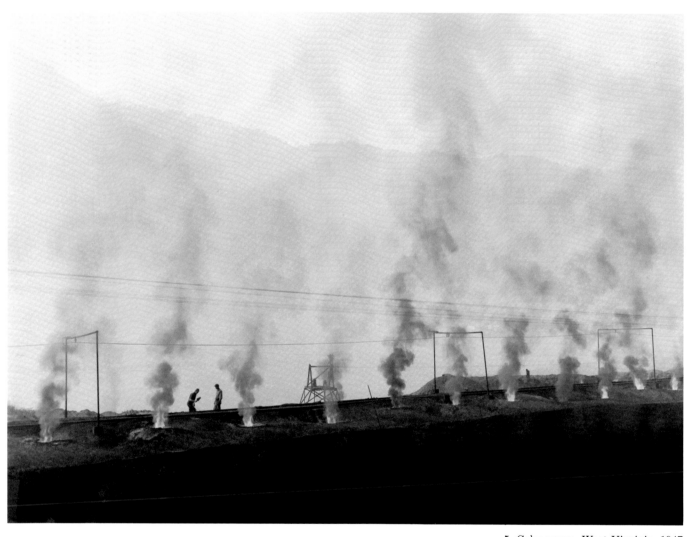

5. Coke ovens, West Virginia, 1947

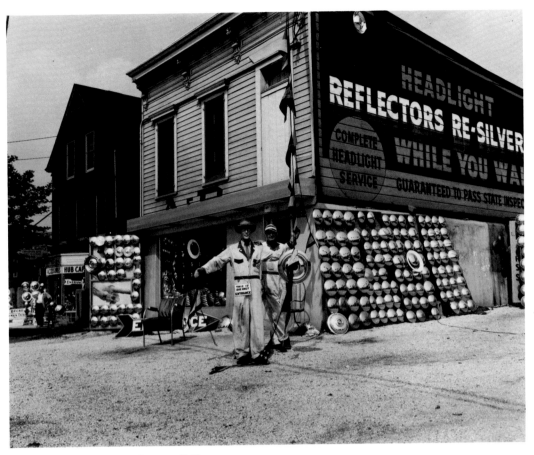

6. Hub cap display, New Jersey, 1947

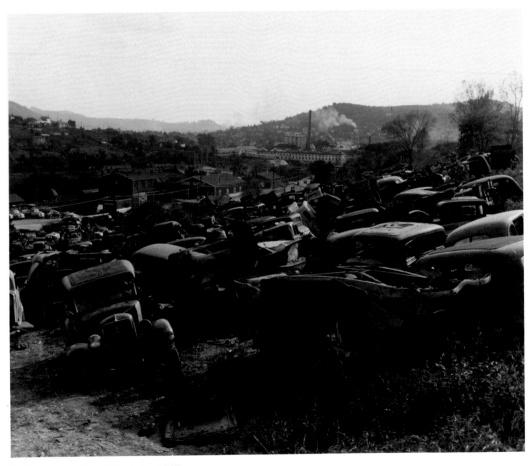

7. Junkyard, West Virginia, 1947

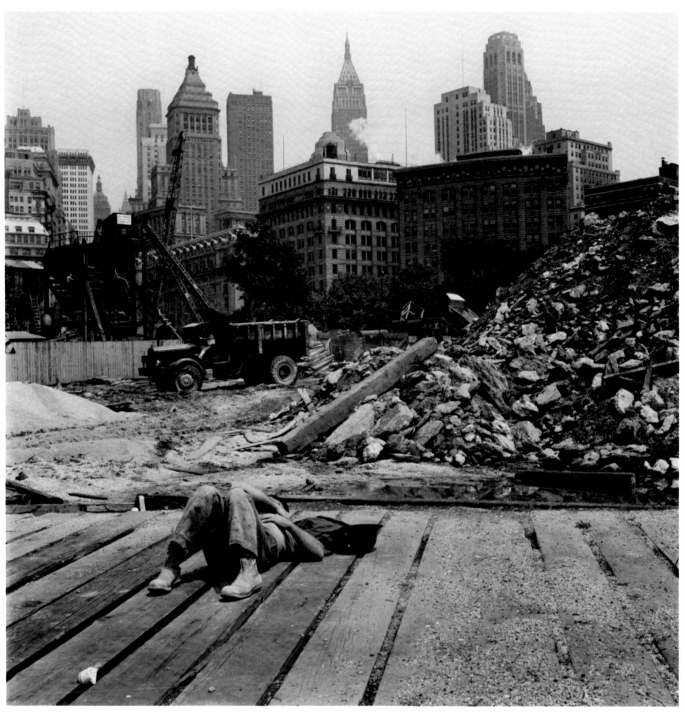

8. Tunnel worker resting, New York City, 1948

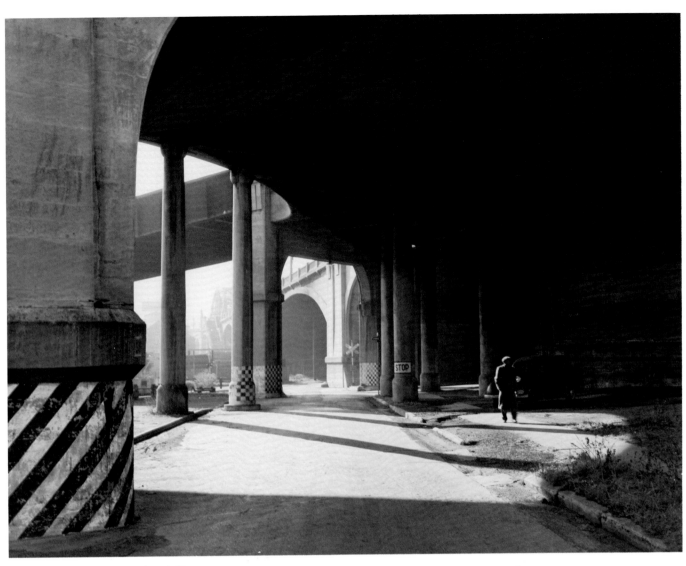

9. Bethlehem, Pennsylvania, 1947

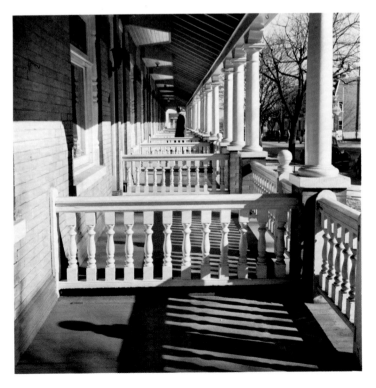

10. Rowhouses, Pennsylvania, 1947

34

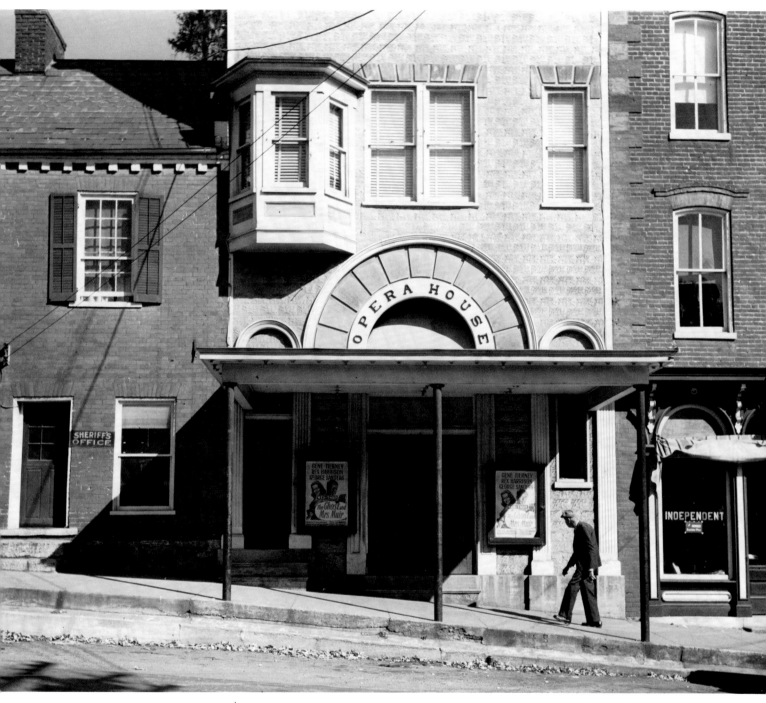

11. Main Street, West Virginia, 1947

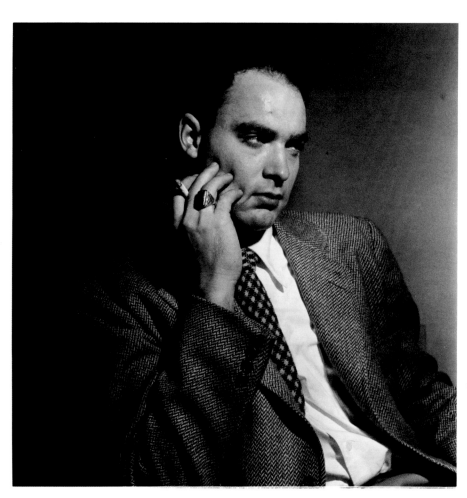

ca. 1946. Photographer unknown.

Harold Corsini

Harold Corsini, just twenty-four years old at the time of his first Standard Oil assignment in December 1943, worked longer for Stryker at Jersey Standard than any other project photographer. Born in 1919, Corsini worked as a freelance photographer in New York and spent three years assisting Arnold Eagle, another Standard Oil photographer, as a photography teacher for the National Youth Administration. In April 1938, Corsini first saw the work of the FSA historical section at the First International Exposition at Grand Central Palace in New York. Fascinated by the FSA images, Corsini realized "that that was the direction in which photography really ought to go." Anxious to take up the documentary style practiced by the FSA photographers, in 1938 Corsini joined the Photo League, "the only free camera club in New York City," whose members practiced "the kind of [socially-concerned] photography that was popular then." Gradually, his work found its way into publications and exhibitions.

Stryker sent Corsini to Norman Wells, Canada, where he spent several weeks struggling against the bitter cold while photographing a Standard Oil exploration and drilling project, and then to the South, where he documented the company-controlled Plantation Pipeline, a major conduit for pumping the company's oil products from its refinery in Baton Rouge to the Northeast. Corsini sent Stryker several detailed, and often amusing, accounts of his experiences in the field. In one such letter he related several colorful anecdotes concerning the difficulties the pipeline affiliate encountered in its work. Going to great measures to obtain the right-of-way for the pipeline, the company, reported Corsini, "gave a widow a black lace gown to be buried in,

gave a hermit a supply of paregoric to which he was addicted, [and] built a rifle range for a woman so she could practice her shooting."[1]

After a brief interlude spent in Asia as a photographic correspondent for the Petroleum Administration for War, Corsini went to Oklahoma in the spring of 1946. In McClain County, he took several hundred photographs of oil drilling activities and oil field workers (Plates 18–20). From McClain County, he drove north to the oil boom town of Cushing. Founded in 1892, Cushing had grown modestly until the surrounding oil fields were opened in 1912; its population rose steadily during the 1920's and 1930's before leveling off at about 8,000 persons during the 1940's. Writing to Stryker, Corsini lamented that in Cushing "everything is so raw, so new, so . . . inexperienced and wasteful that it is difficult to view things objectively."[2] Nevertheless, he found a wide variety of subjects in Cushing to capture with his camera (Plates 12–16), including a shoe repair shop, a service station operator, and the town's firefighters.

Corsini's next subject was Standard's immense refinery at Baytown, Texas, near Houston. His work there attests to his preoccupation with photographic style.

I was interested in the total design of the picture. A photograph is made, first of all, of subject matter. That's most important. Secondly, it's how you arrange the elements in the picture—where you put them—what you include—then what you take out—what angle you point the camera at . . . I would arrange things into conventional compositions . . . In other words, I was designing the picture, and I would do that more than anyone else [in the project].

While other project photographers might say, "'This is the way I see it, this is the way the world is, this is the way I'm going to photograph it,'" Corsini preferred to take a somewhat different approach:

"This is the way I see it, this is the way I think it should look." I'd manipulate the scene more than anyone else—not to the extent of falsifying things, but I would pick my camera angle differently than other people. I would ask the persons I was photographing to turn a certain way so that the light would hit them a certain way. And I would take all the elements there and manipulate them to my satisfaction—to what I thought was best.

Corsini's powerful photograph of empty coveralls on a clothesline (Plate 124), taken in June 1946, and his shot of an oil driller as seen from beneath the drilling floor (Plate 19) are clear illustrations of his interest in making carefully composed, aesthetically pleasing images.

During the final four years of the project, Corsini remained an extraordinarily productive photographer. He left Standard Oil in 1950 to assist Stryker at the Pittsburgh Photographic Library. Remaining in Pittsburgh, Corsini retired in 1975 after running his own commercial photography business.

1. Letter from Harold Corsini to Roy Stryker, 13 May 1944, Stryker Collection.
2. Letter from Harold Corsini to Roy Stryker, 21 May 1946, Stryker Collection.

12. Street scene, Cushing, Oklahoma, 1946

13. An old resident, Cushing, 1946

14. Shoe repair shop, Cushing, 1946

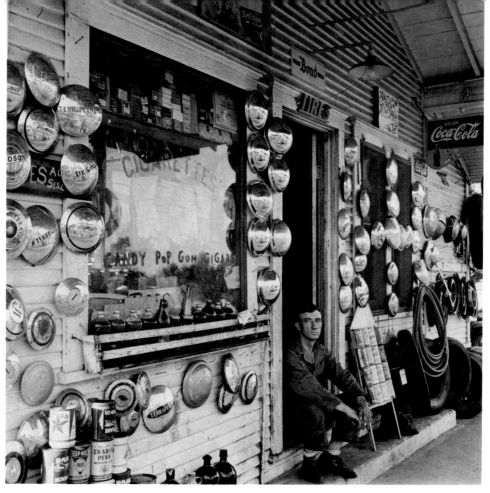

15. Service station owner, Cushing, 1946

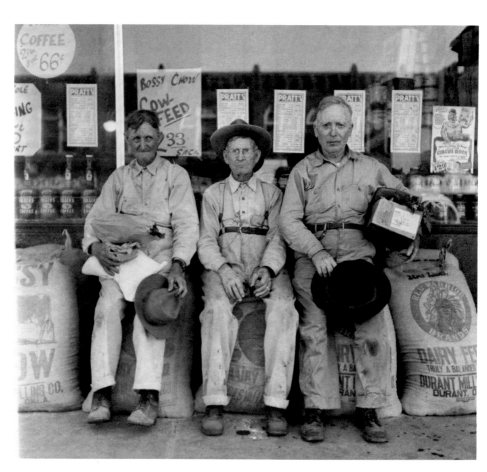

17. Farmers shopping in Purcell,
Oklahoma, 1946

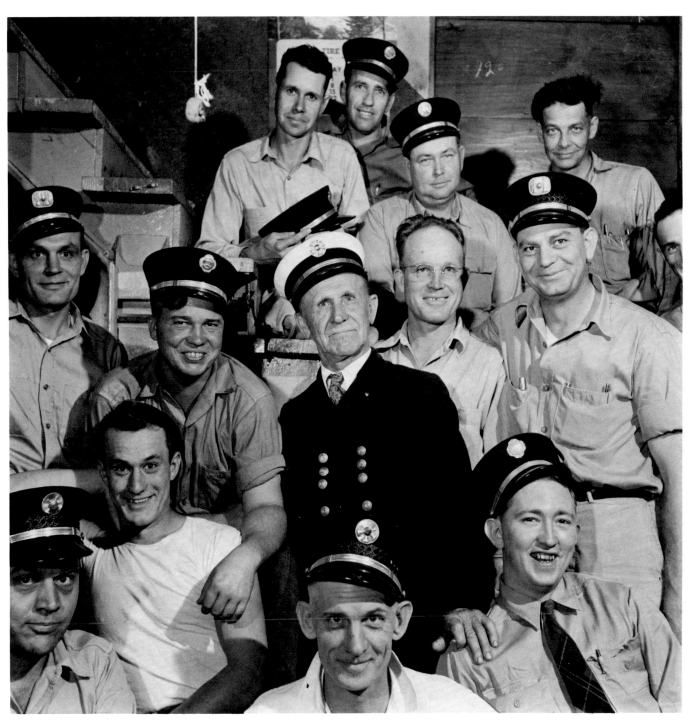

16. Fire department personnel, Cushing, 1946

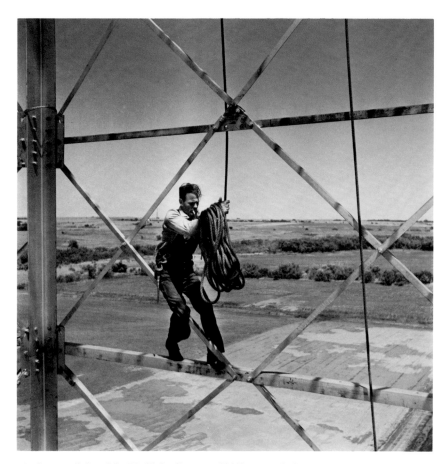

18. On an oil derrick, McClain County, Oklahoma, 1946

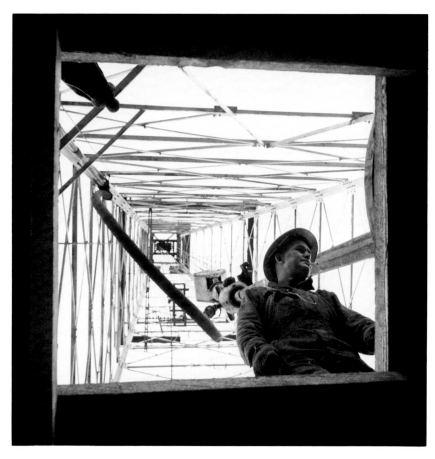

19. Driller seen from beneath drilling floor, McClain County, 1946

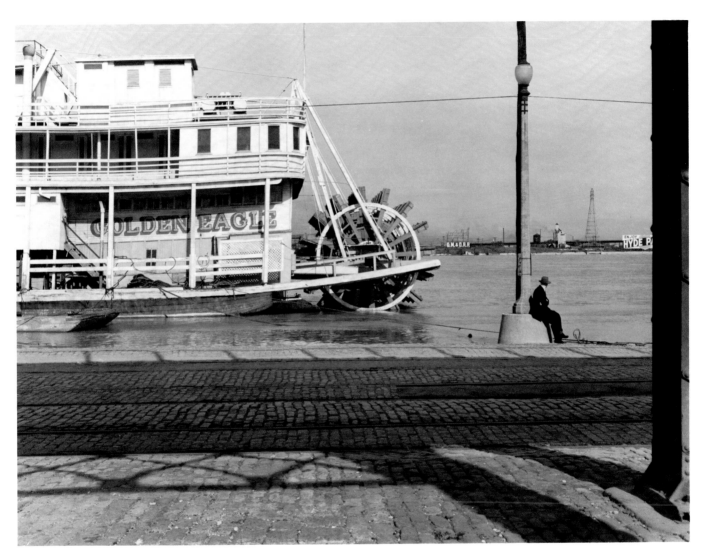

22. On the riverfront, St. Louis, 1945

Edwin and Louise Rosskam

Edwin Rosskam had worked for Roy Stryker at FSA as a writer, editor, and layout specialist from 1938 until late 1943, when he and his wife Louise embarked on their first assignments as Standard Oil project photographers. The Standard Oil project offered Edwin Rosskam his first opportunity to *take* rather than edit and write about photographs. "In Farm Security, much as I wanted to take pictures," says Rosskam, "I never got the opportunity . . . Before I moved over with Roy to Standard, I said, 'Look, I'm not going unless I'm a photographer!'" Stryker gladly granted Rosskam's demand.

Born in 1903, Edwin Rosskam was detained in Germany during World War I with his American father and German mother while his two older brothers served in the American armed forces. After emigrating to America in 1919, he studied painting at the Philadelphia Academy of Fine Arts for four years before journeying to Paris, where he lived and painted until 1929. A largely self-taught photographer, Edwin spent several years in Polynesia selling occasional stories and photographs to European publications. He moved on to Philadelphia, where he married Louise in 1936.

The Rosskams soon joined the staff of the *Philadelphia Record* "as the first photographic team that ever happened in Philadelphia." Although she had planned to become a geneticist, Louise Rosskam's scientific career was sidetracked by several distinguished friends in Greenwich Village, including "[the arctic explorer Vilhjamur] Stefansson and Bucky Fuller and a bunch of dancers, artists, [and] writers" who shattered her "concepts of biology." Soon, she began working with a Rollei camera and discovered that her "ability in photography was catching all those little moments that you don't plan."

While Edwin often "photographed a theme on a grand scale, composed and exquisite from the point of view both of the subject and the composition," Louise preferred to "catch all the peripheral stuff that was going on." Their working as a team, she believes, tended to allow their subjects to "feel more relaxed in difficult situations."

In January and February 1944, early in the Standard Oil project, the Rosskams photographed the company's Baton Rouge and Baytown refineries in great detail (Plates 121, 123). Praising the four hundred photographs the Rosskams made at Baton Rouge, Stryker later wrote that the Rosskam photographic team had

made a complete pictorial record of pipes, "cat" crackers, and fractionation towers but they also gave, in their pictures, the sense that refineries would be meaningless labyrinths of strange forms if it were not for the men and women who control and maintain them. Rosskam cameras and knowing eyes searched into every phase of life in a refinery. They related the landscape to machines and the machines to the men.[1]

During the summer of 1944, the Rosskams spent several weeks documenting the activities of the Carter Oil Company, a Jersey Standard affiliate in Elk Basin, Wyoming, and the remote oil drilling community of Cut Bank, Montana. Their coverage of both areas was as broad as it was deep. In Elk Basin, the Rosskams not only photographed the efforts of petroleum geologists and drillers, but also documented the "peripheral stuff," including a worker proudly polishing the chrome grill of his automobile (Plate 31) and an amateur radio performance in Powell, Wyoming, by a singer known as the "Catskinner from Elk Basin" (Plate 30). Edwin Rosskam's view of an oil train traversing the prairie between Cut Bank

and Browning, Montana, taken in August 1944, became one of the project's best-known photographs (Plate 27).

The February 1944 edition of the Standard Oil company magazine, *The Lamp*, carried the Rosskams' "picture story" entitled "Muddy and Mean," an account of their trip down the Mississippi from Memphis to Baton Rouge aboard the company towboat *Jack Rathbone* (Plate 24). The popularity of this article led Stryker to assign the Rosskams to spend the better part of 1945 continuing the work they had begun on the Mississippi in 1943. For two months, says Edwin Rosskam,

we recorded ninety hours of the speech of the river. We recorded pilots, engineers, deckhands, pumpmen, cooks, maids, wives, traffic experts, designers, shippers, and even a general (retired). We got what they had to say in their own words.[2]

From their recordings and photographs came *Towboat River*, a "collaboration between the authors and the people of the river," published in 1948.[3] Their book, according to Edwin Rosskam, "was the first, at least in the U.S.A., to combine recorded words with photographs—a wholly documentary work."[4]

In 1946, the Rosskams left Standard Oil to begin a documentary photography project in Puerto Rico similar to that done for the Farm Security Administration during the 1930's. Since returning to the mainland in 1953, they have lived in Roosevelt, New Jersey, and worked on a number of publications and slide presentations.

1. Stryker, "Documentary Photography in Industry," p. 323.
2. Edwin and Louise Rosskam, *Towboat River*, p. 6.
3. Ibid.
4. Edwin Rosskam, "Witness to the '40's" (manuscript, n.d.), Stryker Collection.

ca. 1944. Photographer unknown.

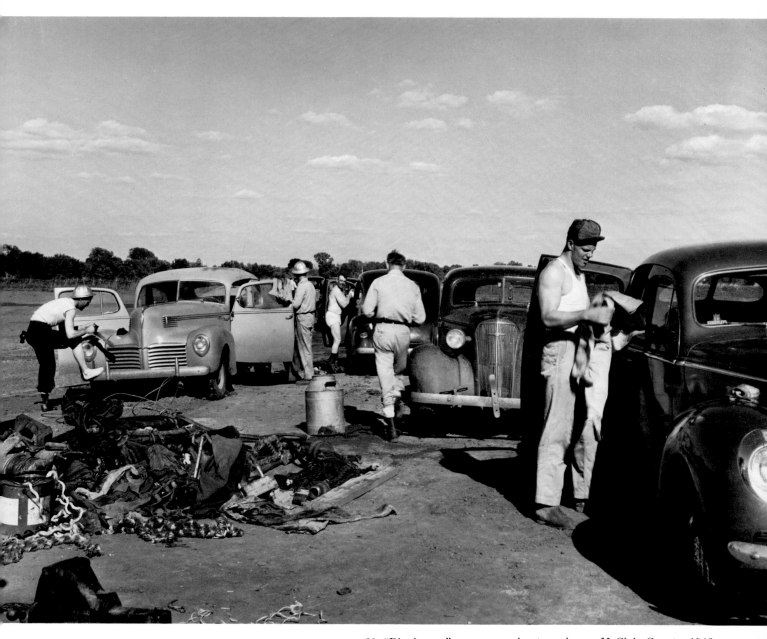

20. "Rigging up" crew preparing to go home, McClain County, 1946

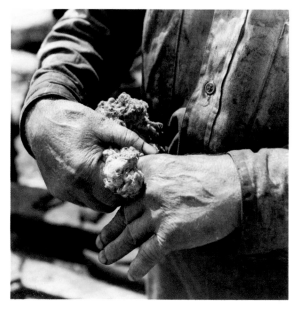

21. Hands of a driller's helper,
Union County, Kentucky, 1944

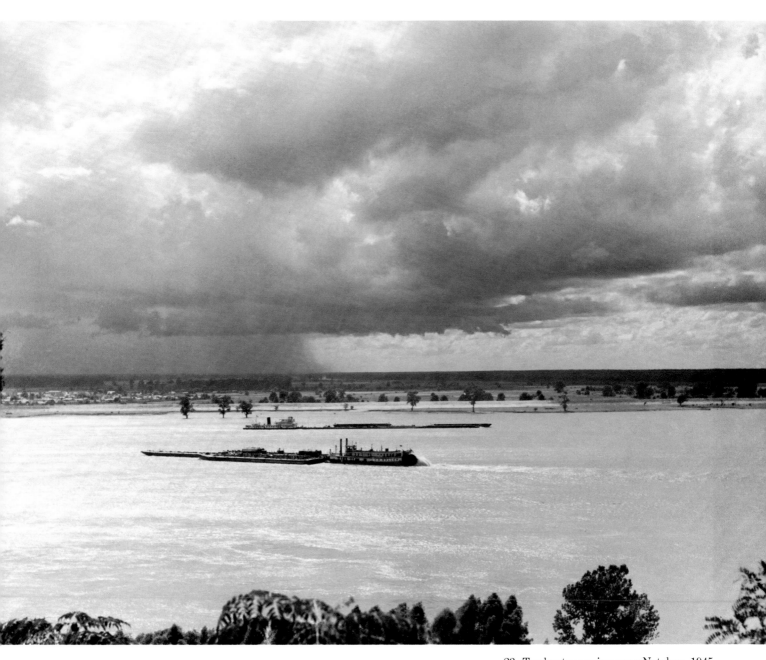

23. Towboats passing near Natchez, 1945

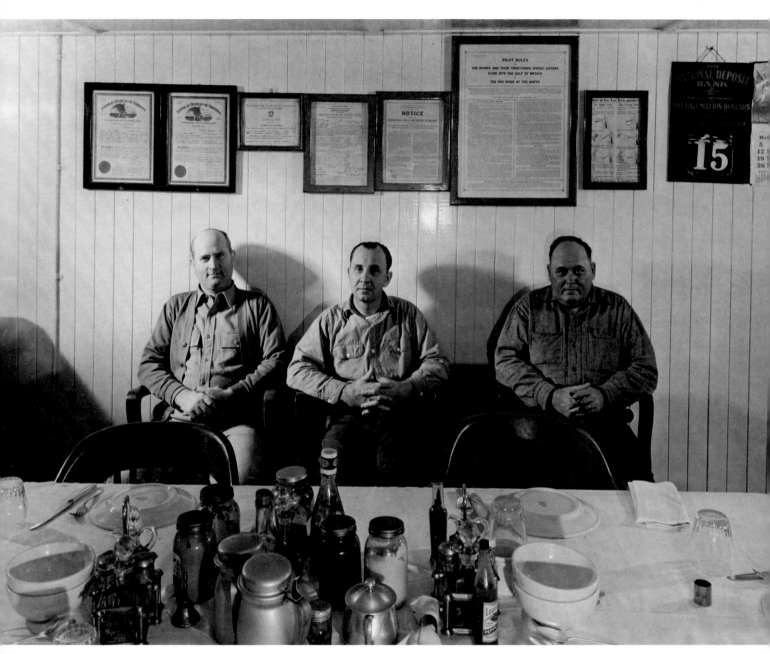

24. Towboat officers, Mississippi River, 1943

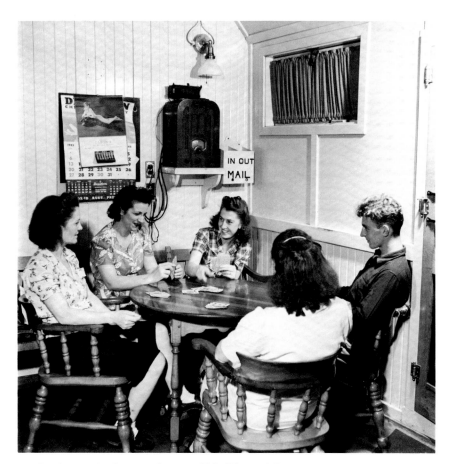

25. Card game in the crew lounge, Ohio River, 1945

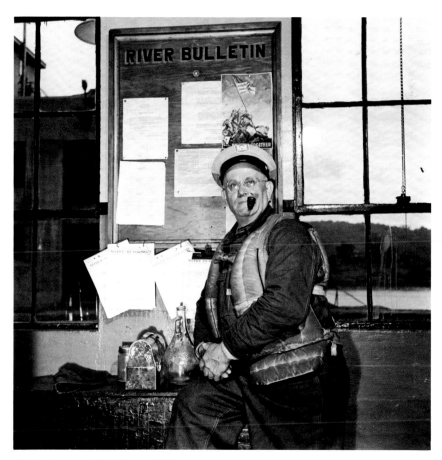

26. Lockman, Ohio River, 1945

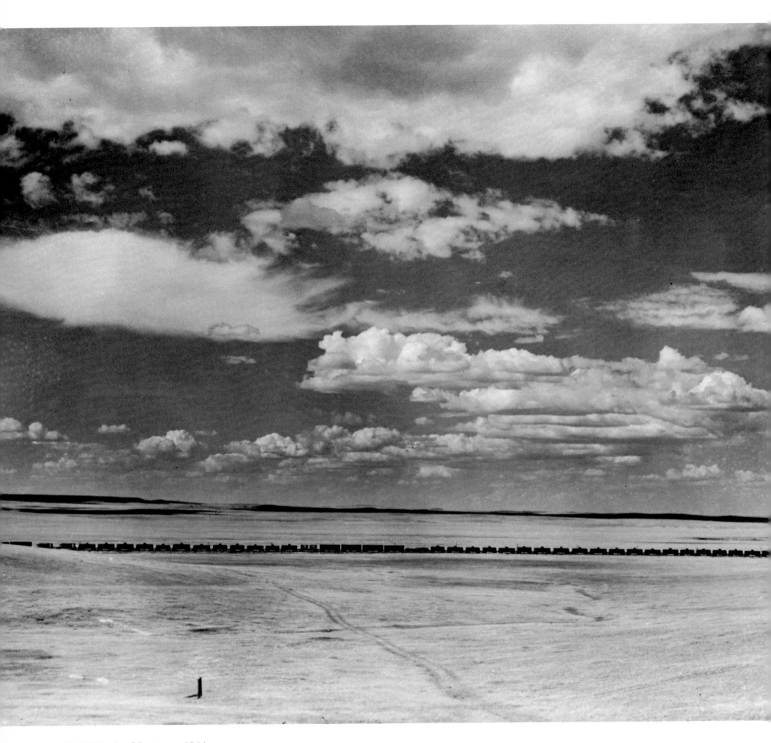

27. Oil train, Montana, 1944

29. Oil men in a restaurant, Wyoming, 1944

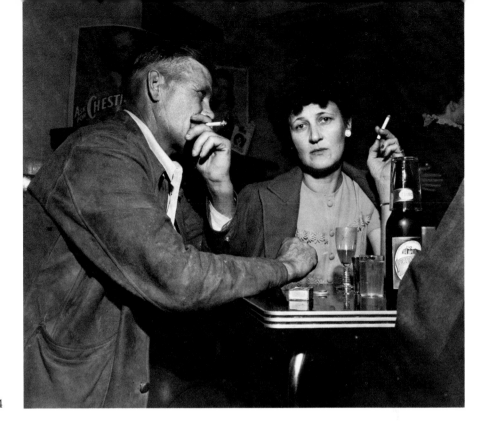

28. Joe's Bar, Montana, 1944

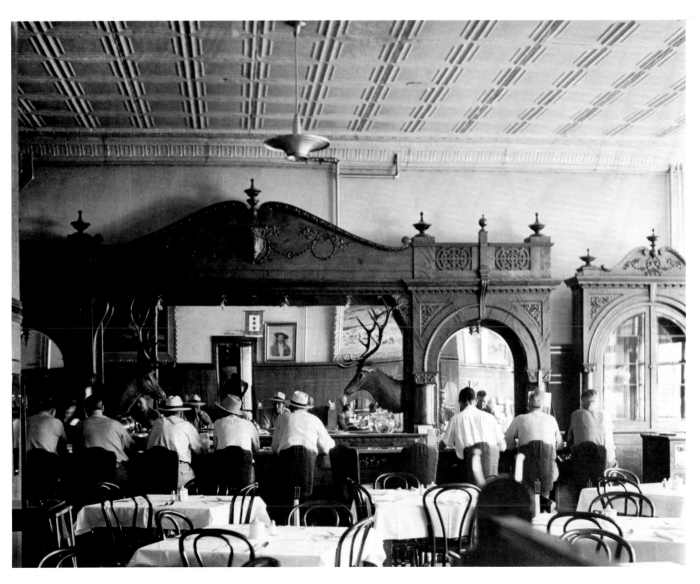

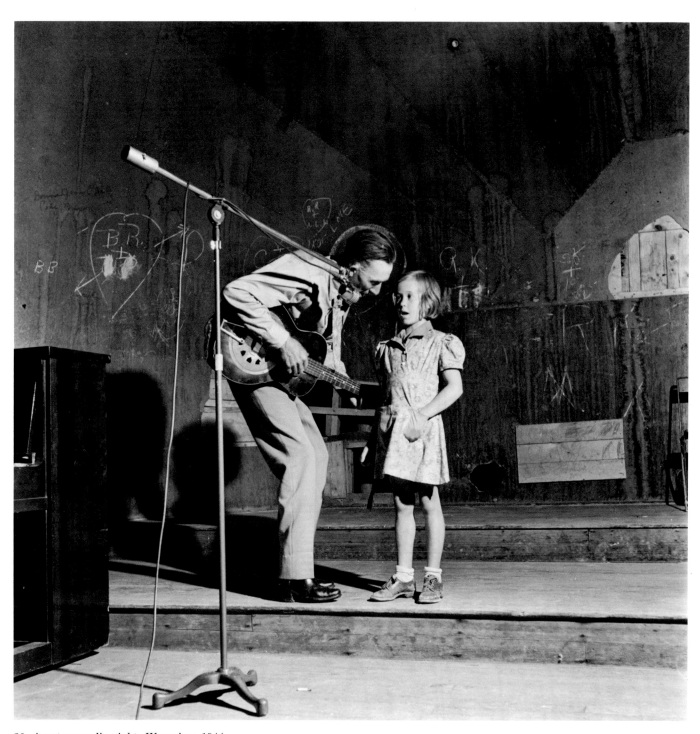

30. Amateur radio night, Wyoming, 1944

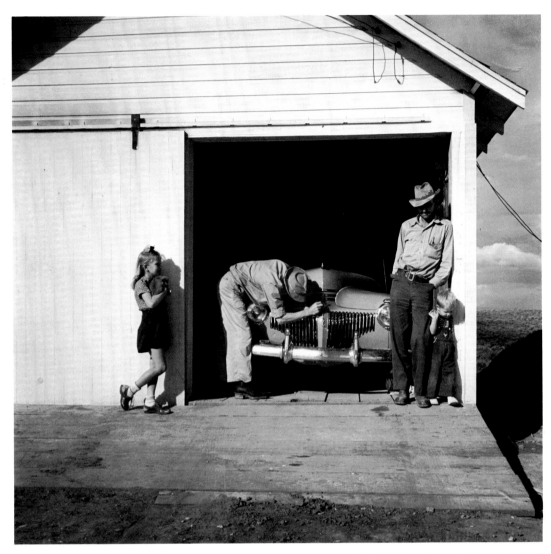

31. Washing the car, Wyoming, 1944

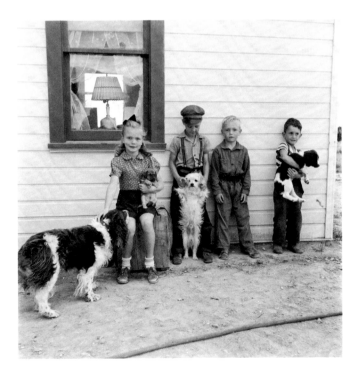

32. Oil town children,
Wyoming, 1944

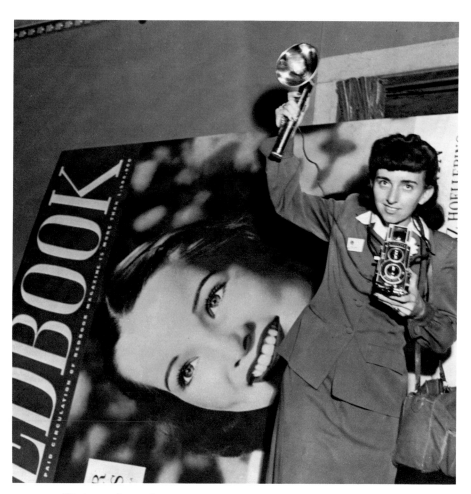

ca. 1945. Photographer unknown.

Esther Bubley

Like John Vachon and Edwin Rosskam, Esther Bubley accompanied Roy Stryker from Washington to Standard Oil's headquarters in New York at the beginning of the company project.

The daughter of an automobile supply store manager, Bubley left her home in Superior, Wisconsin, in the late 1930's to study painting at the Minneapolis School of Design. Eventually, she grew more interested in photography. From time to time, Bubley noticed photographs by the Farm Security Administration published in magazines. In 1940 she moved to Washington, hoping to find work as a photographer before heading on to New York where, with the assistance of Edward Steichen, she secured a temporary studio job at *Vogue Magazine*.

In 1941, Bubley took a position as a microfilmer in the National Archives. Several months later, Roy Stryker hired her as a lab technician for the FSA darkroom. While not on the agency's payroll as a photographer, Bubley nevertheless took a small number of photographs and began receiving photographic assignments just as Stryker and the FSA historical section were being transferred to the Office of War Information.

In April 1945 Bubley drove to Texas. Her first stop was Tomball, a small oil boom town near Houston occupied largely by employees of the Humble Oil and Refining Company (an affiliate of Standard Oil of New Jersey). In less than six weeks Bubley created an extraordinarily thorough record of the town, capturing in her six hundred photographs subjects such as a meeting on VE Day, women chatting in the City Cafe, and men relaxing over a domino game (Plates 33–39). In July, Bubley made her way across West Texas, stopping at Andrews, a town of just over three thousand people. There, she continued her documentation of small-town Texas, making, among

several hundred other images, photographs of a lonely horse and automobiles on Main Street, conversation in a drug store, and an oilfield roustabout and his family at home in their tent (Plates 40–43).

Bubley's "Bus Story" photographs (Plates 111, 112) were widely disseminated in the popular press and won the top prize in the picture sequence category in a photography contest cosponsored by the University of Missouri and *Encyclopaedia Britannica*. As Anne Adams, Bubley's longtime friend and the former managing editor of Standard Oil's company magazine *The Lamp*, has said,

Esther Bubley's work had a great warmth to it as far as people were concerned. I never think of Esther as just doing a scene. I think of people when I think of Esther and a great warmth and feeling for women, children, and men. She was interested in humanity.

Bubley's candid pictures made in the waiting room of the New York Greyhound Bus Terminal illustrate Anne Adams' remarks beautifully.

Bubley left Stryker's project in the late 1940's to work for *Life Magazine*. She has continued to work as a freelance photographer since *Life* ceased publication in 1972.

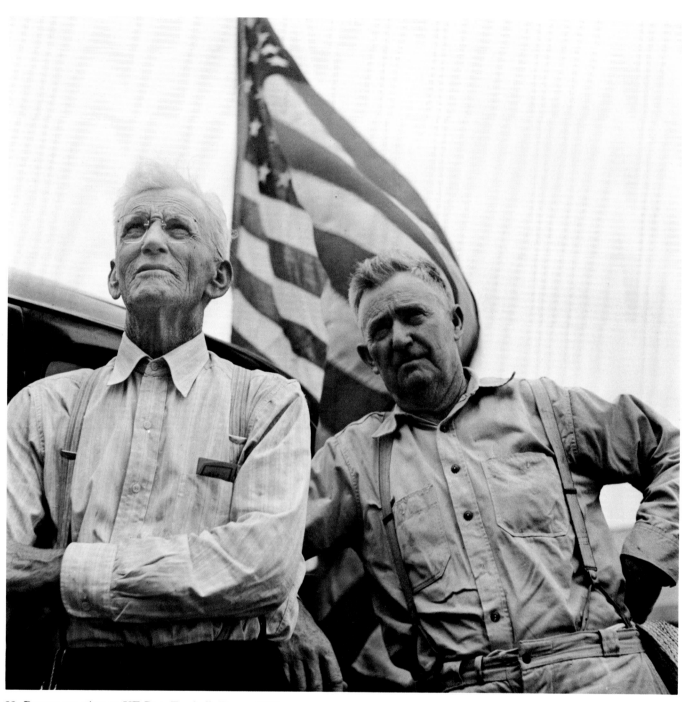

33. Prayer meeting on VE Day, Tomball, Texas, 1945

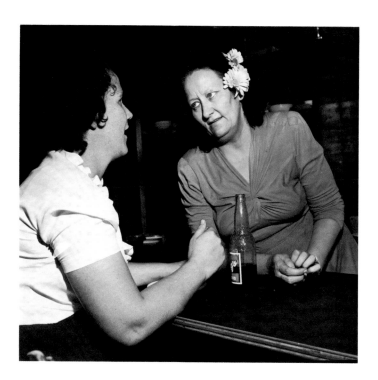

34. The City Cafe, Tomball, 1945

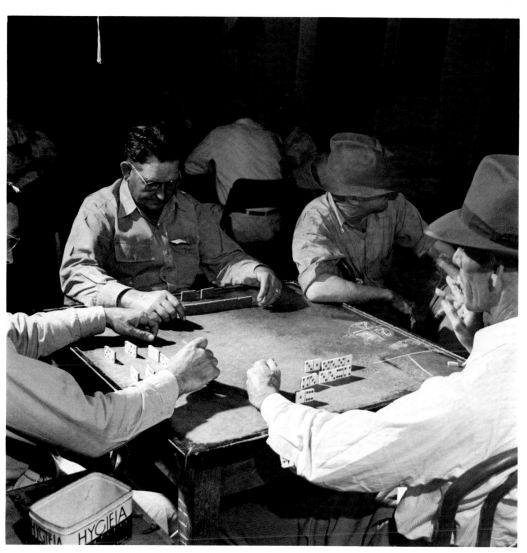

35. Playing "moon," a domino game, Tomball, 1945

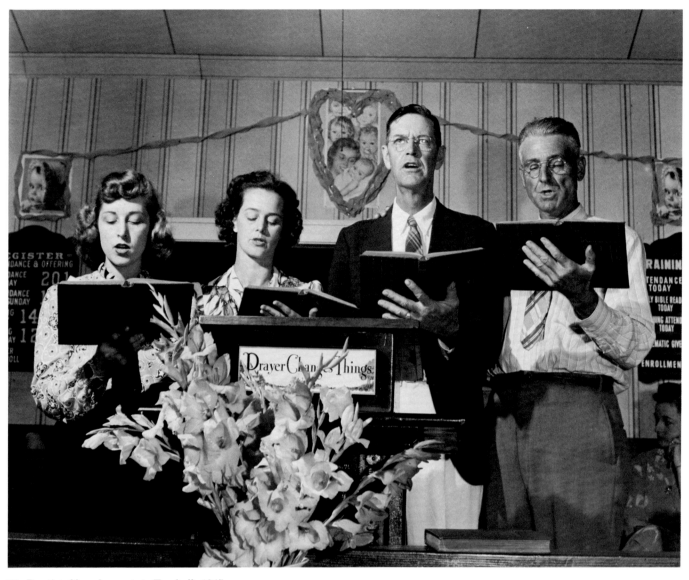

36. Baptist Church quartet, Tomball, 1945

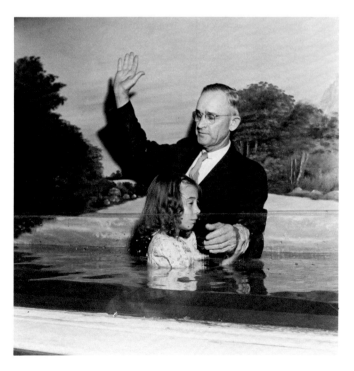

37. Baptism, Tomball, 1945

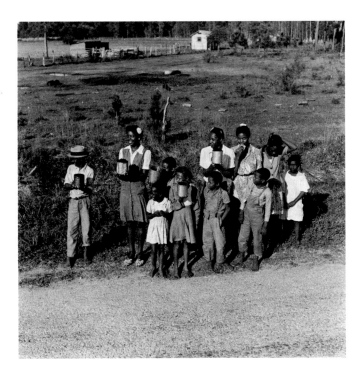

38. Selling berries between Houston and Tomball, 1945

39. Feed store, Tomball, 1945

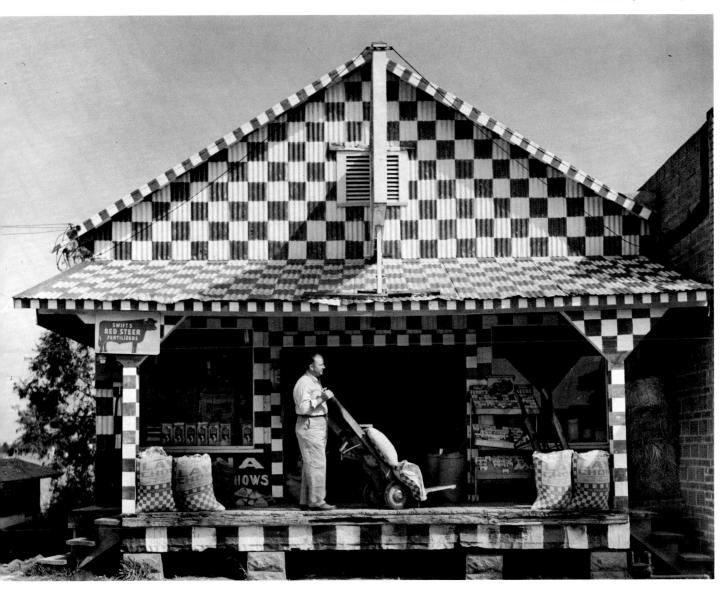

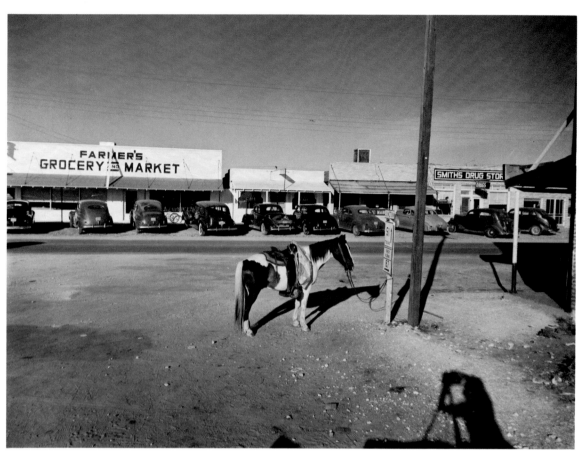

40. Main Street, Andrews, Texas, 1945

41. Drug store conversation, Andrews, 1945

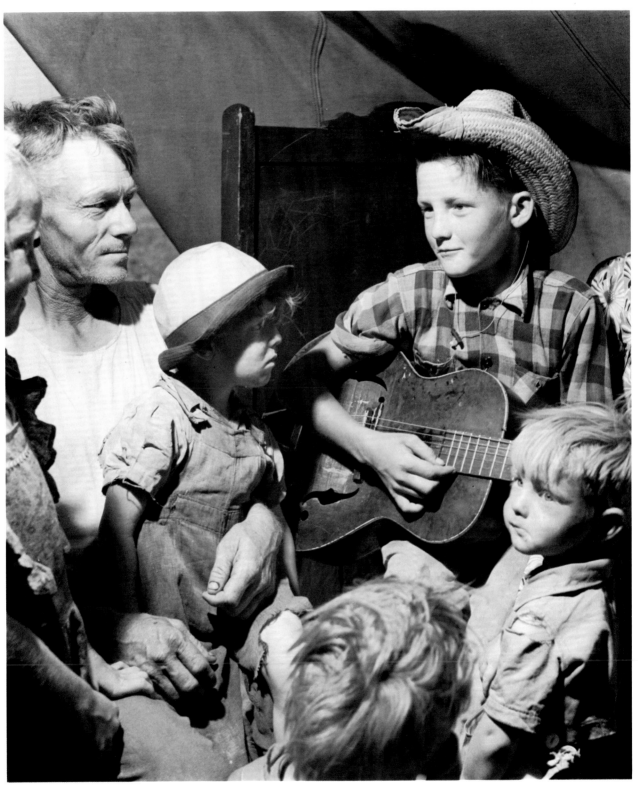

42. Oilfield family in their tent, Andrews, 1945

43. Oilfield roustabout with children, Andrews, 1945

44. A boy's dresser-top, Bandera County,
Texas, 1945

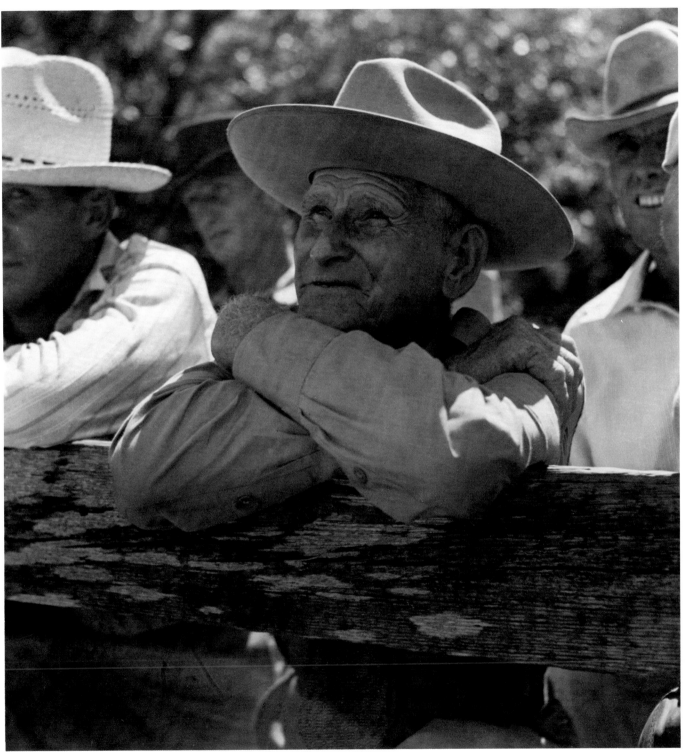

45. Rodeo spectator, Utopia, Texas, 1945

ca. 1944. Photographer unknown.

Gordon Parks

Gordon Parks' career has been long and richly varied. Born in 1912 in Fort Scott, Kansas, Parks worked as a nightclub pianist, semiprofessional basketball player, and railroad waiter before taking up photography in 1937. With the encouragement of FSA photographer Jack Delano, Parks applied for and received the first Julius Rosenwald Fellowship in photography in 1942. He chose to spend his fellowship studying in Washington, D.C., under Roy Stryker at FSA and later OWI.

Parks came to the Standard Oil project almost by accident. Upon leaving Stryker's OWI unit in 1943, Parks hoped to spend World War II attached as a photographer to the legendary black pilots of the 332nd fighter group. His plans were thwarted, though, by a "Southern Congressman who didn't want to see that kind of money spent sending me as a war correspondent."

Stryker soon offered the disappointed Parks a series of assignments for Standard Oil. In March 1944, Parks went to the company's Pittsburgh Grease Plant, where he made a detailed photographic series of its workers (Plate 52). During the summer of 1944, he made his way to Maine, where he enjoyed "just photographing American scenes." In Skowhegan, Maine, he made a pair of portraits of a farm couple which bring to mind Grant Wood's painting *American Gothic* (Plates 50, 51).

At Standard Oil, Parks was particularly "interested in the aesthetics of photography . . . [making his work] . . . as unusual as I possibly could through the use of the camera." Returning to New England in October 1947, Parks made two eloquent photographs of rural Vermonters preparing for the onset of winter, an elderly woman seen through the window of her well-stocked farmhouse and farmers spreading hydrated lime on the land (Plates 48, 49). He also made hundreds of other portraits for Standard Oil, including that of an eighty-seven-year-old portrait photographer (Plate 53) and an imaginative, oblique view of New York City commuters on the Staten Island ferry (Plate 54).

After leaving Standard Oil in 1948, Parks realized his ambition to become a staff photographer for *Life Magazine*. Besides his work in photography, Parks directed the films *Leadbelly*, *Shaft*, and *The Learning Tree*. He has also written a number of books, including his autobiographies, *A Choice of Weapons* and *To Smile in Autumn*, and composed numerous piano concertos and a symphony. He has lived in New York City for more than forty years.

46. Dinner table, Maine, 1944

47. Main Street scene, Massachusetts, 1945

48. Farmhouse, Vermont, 1947

49. Spreading lime, Vermont, 1947 50. Farmer, Maine, 1944 51. Farmers, Maine, 1944

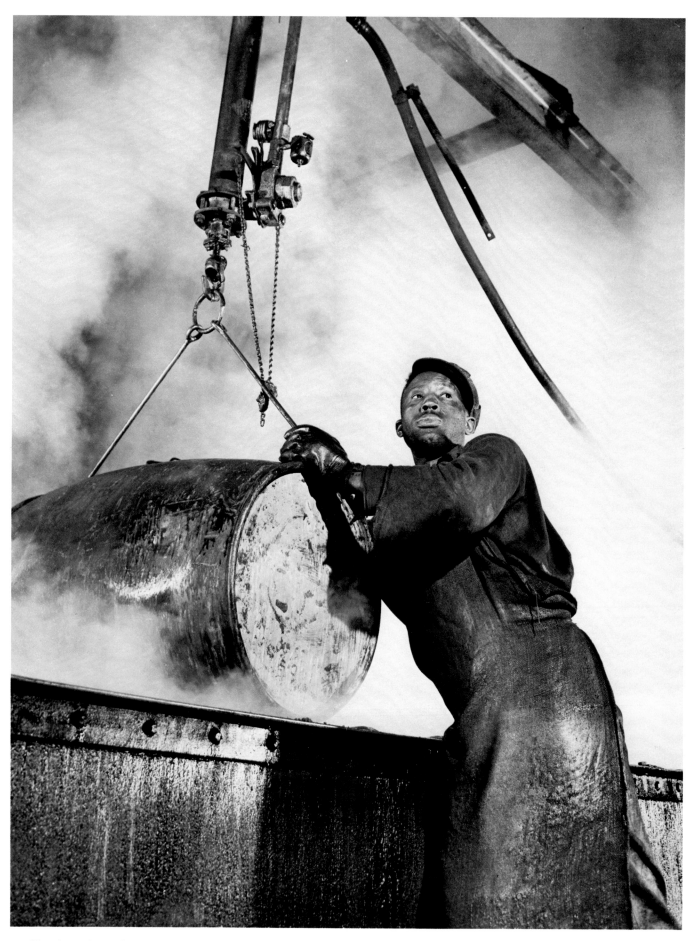

52. Cleaning a drum, Pittsburgh, 1944

53. Portrait photographer, New York, 1946

54. Commuters, New York City, 1946

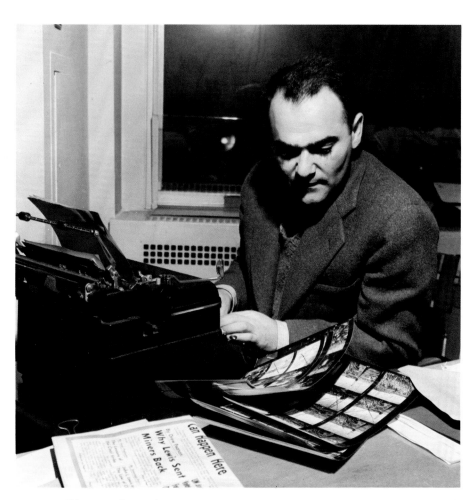

ca. 1946. Photographer unknown.

Sol Libsohn

Sol Libsohn was one of the Standard Oil project's most prolific photographers. In just under five years, he took nearly six thousand photographs for the company's files.

Born in New York City in 1914, as a youth Libsohn repaired a broken Kodak "Brownie" camera given by a neighbor and learned to take pictures by simply "going out in the streets and photographing." He attended City College in New York during the Depression years and was a major participant in the Photo League, an important organization of socially concerned photographers whose members included Aaron Siskind, Sid Grossman, and Morris Engel.

Shortly after Roy Stryker arrived at Standard Oil, he came across a series of portraits by Libsohn in a social work magazine. Stryker liked what he saw. He offered Libsohn an assignment across the Hudson River at Standard Oil's Bayonne, New Jersey, refinery. There, Libsohn made a series of portraits of company employees with forty or more years of service. The pictures were published by the Public Relations Department in early 1944 as a two-page advertisement run in several New Jersey newspapers.

Pleased with Libsohn's handling of the Bayonne assignment, Stryker sent the new project photographer on the road to Chester, Pennsylvania, where the Sun Shipbuilding Company was building oil tankers for Standard Oil. Libsohn's photographs ably conveyed a sense of the awesome scale of shipyard operations (Plate 120).

Two groups of Sol Libsohn's Jersey Standard photographs deserve special mention. The first, known as the "Trucking Story," grew out of a two-month-long assignment during which Libsohn followed truckers on their interminable runs. Besides depicting petroleum's key role in the trucking industry, Libsohn's photographs offered a revealing look at the truckers' grueling existence in the days before the building of America's interstate highway system (Plates 55–60).

Judging from his work, Libsohn especially enjoyed photographing the myriad ways in which Americans relaxed and played during the 1940's. Among his best photographs of Americans at leisure are those of a soldier home on furlough unwinding with old friends at a general store (Plate 61) and a motorcycle sideshow barker making his pitch at a state fair (Plate 65). In 1946, Libsohn gained Stryker's blessing to do an in-depth "picture story" on the Ringling Brothers Circus. As Libsohn explained,

I always liked the circus in the sense that they were a microcosm of what we're all about. It was a city that was moving all around, all over the place and all dressed-up . . . And I figured they used oil products.

Libsohn made approximately 150 photographs of nearly every conceivable element of circus life, from midgets to elephants (Plates 64, 66).

After leaving the Standard Oil project in 1950, Libsohn worked as a freelance photographer before teaching photography at Princeton University and Bucks County Community College near his New Jersey home.

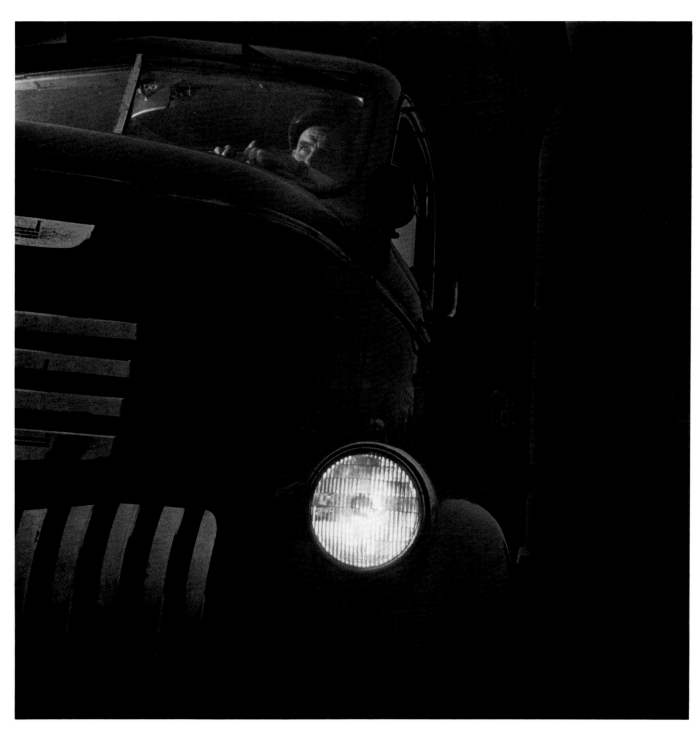

55. U.S. 22, Pennsylvania, 1945

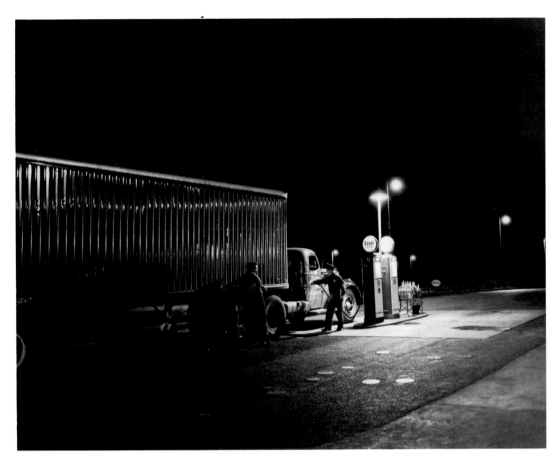

56. Refueling on the Pennsylvania Turnpike, 1945

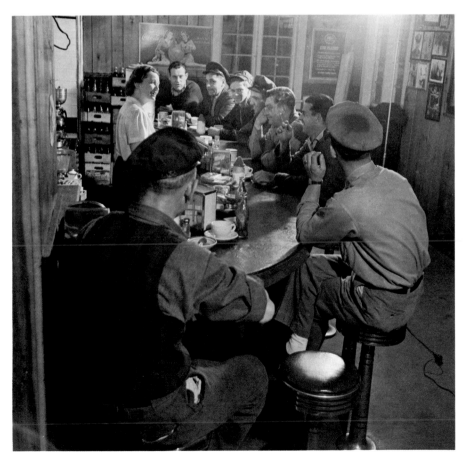

57. Lunch counter in a diner, New Jersey, 1945

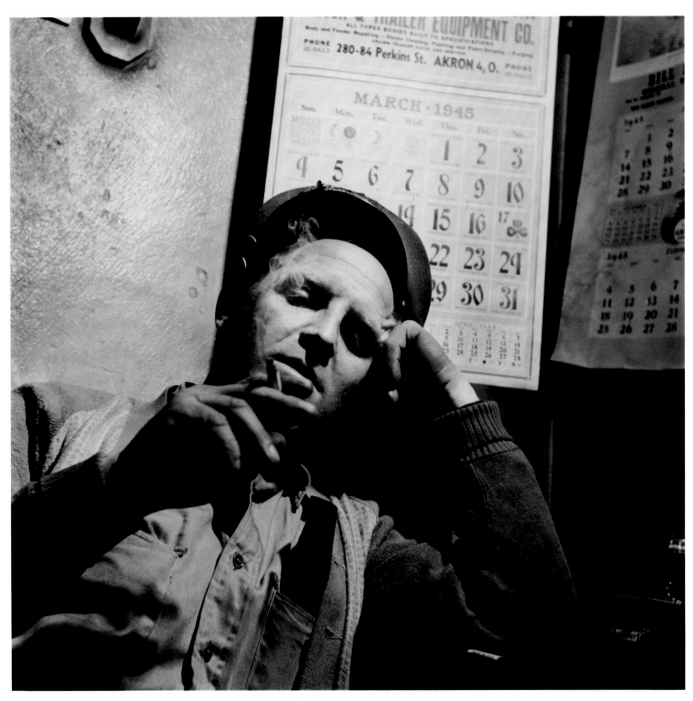

58. Truckdriver after a run, Ohio, 1945

59. Restaurant counter, Pennsylvania, 1945

60. Waking up at a truckstop, Pennsylvania, 1945

61. Soldier on furlough, North Carolina, 1944

62. Discussing local matters in a general store, North Carolina, 1945

63. Just before breakfast, Louisiana, 1944

64. Circus elephants at a parade, Pennsylvania, 1946

65. Motorcycle show barker, New Jersey, 1947

66. Circus performer, Pennsylvania, 1946

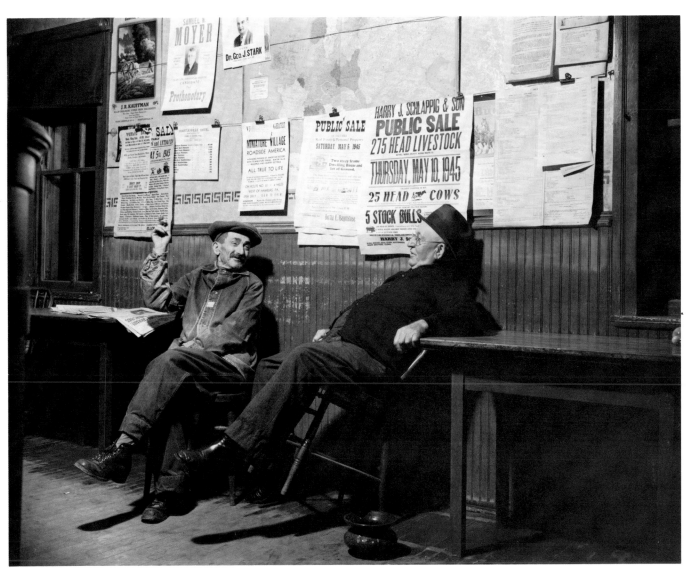

67. Farmers at an inn, Pennsylvania, 1945

August 1944. Photograph by Arthur Rothstein.
Courtesy Charlotte Brooks.

Charlotte Brooks

Charlotte Brooks first met Roy Stryker on 12 April 1945, the day Roosevelt died. Stryker had learned of Brooks through Edwin Rosskam, who had read "Girl on Assignment," an article devoted to her work in the February 1945 issue of *Popular Photography*.

Brooks grew up in New York City. After earning a bachelor's degree from Brooklyn College, she studied clinical psychology at the University of Minnesota, but left the graduate program dissatisfied with its emphasis on "psychometrics." Back in New York once again, she took a job as a social worker in a settlement house and grew interested in modern dance.

Before turning her interest toward photography, Brooks was involved in a semiprofessional modern dance group. As she has recalled,

When I realized that I really wasn't a modern dancer, that I wasn't good enough to be the kind of dancer I wanted to be, and I wasn't a choreographer, I turned to photography so I could photograph dance.

With the help of former FSA photographer Arthur Rothstein, she secured an apprenticeship with Barbara Morgan, the renowned dance photographer. Several months later Brooks found her first paying job in photography as an $18 per week assistant to Gjon Mili, who had adapted Harold Edgerton's strobe light to artistic and commercial photography. After one year spent assisting Mili and photographing in her spare time, Brooks "got itchy" and became a staff photographer for a chain of three newspapers in suburban New Jersey.

After her first Standard Oil assignment—covering a company shareholder meeting—Brooks photographed farming in upstate New York, life in New England towns, the rounds of a rural Vermont mail carrier, and a fair in Bath, New York. Brooks described her Standard Oil work as

largely documentary, with very, very little emphasis on the industrial, remembering all of the time that even the documentary material had roads and all the things that are by-products of the oil industry woven into its fabric.

Looking back on her Jersey Standard days, Brooks says her photographs were "romantic."

I think of myself as being romantic, which is very funny because for a long time I thought I was really doing a sort of objective, documentary style. But when I look at my work now, more and more I see something that could be described more as romantic than as purely objective. I liked fog in the morning, or rain, and weather conditions.

Brooks accepted occasional Standard Oil assignments, taking nearly one thousand photographs for the company over a two-year period.

In 1951, Brooks became the only woman staff photographer ever hired by *Look Magazine*. She remained with *Look* until its demise in 1971. After *Look* halted publication, she freelanced and taught photography near her rural New York home.

68. Farm cellar, New York, 1945

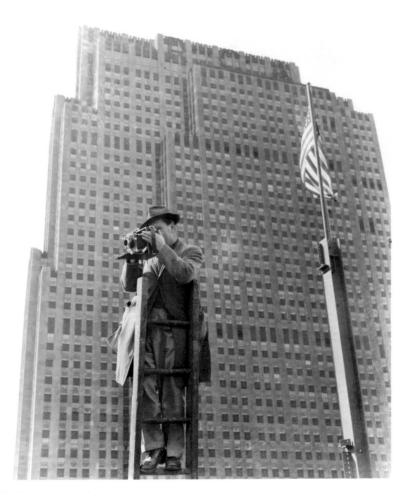

ca. 1946. Photographer unknown.

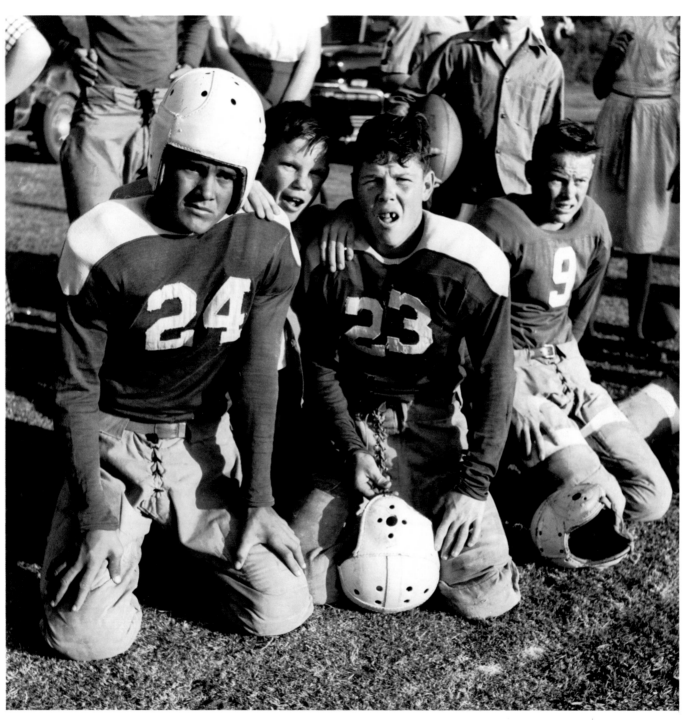

82. Football game, Mississippi, 1947

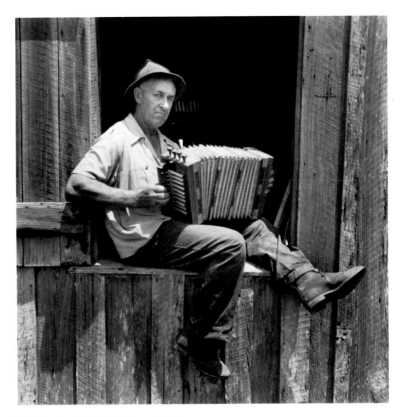

80. Blacksmith, Louisiana, 1947

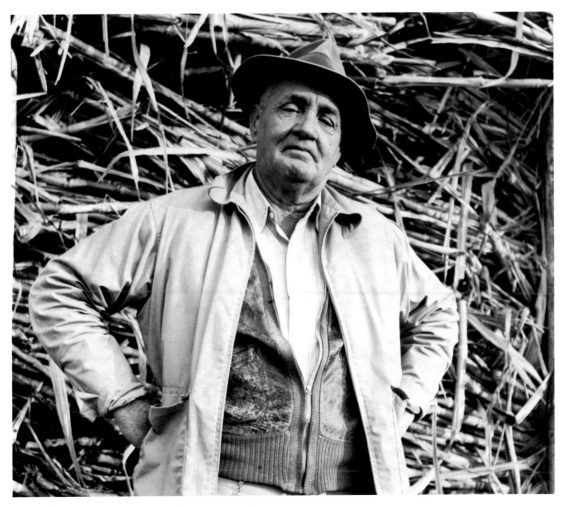

81. Yard man at a sugar co-op, Louisiana, 1946

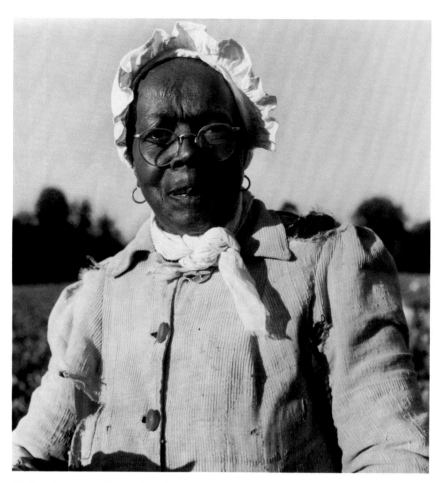

78. Rural woman, South Carolina, 1948

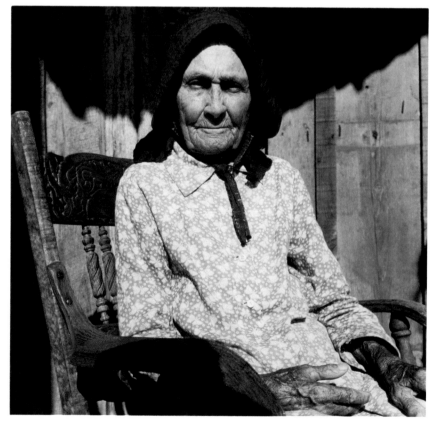

79. Acadian woman, Louisiana, 1947

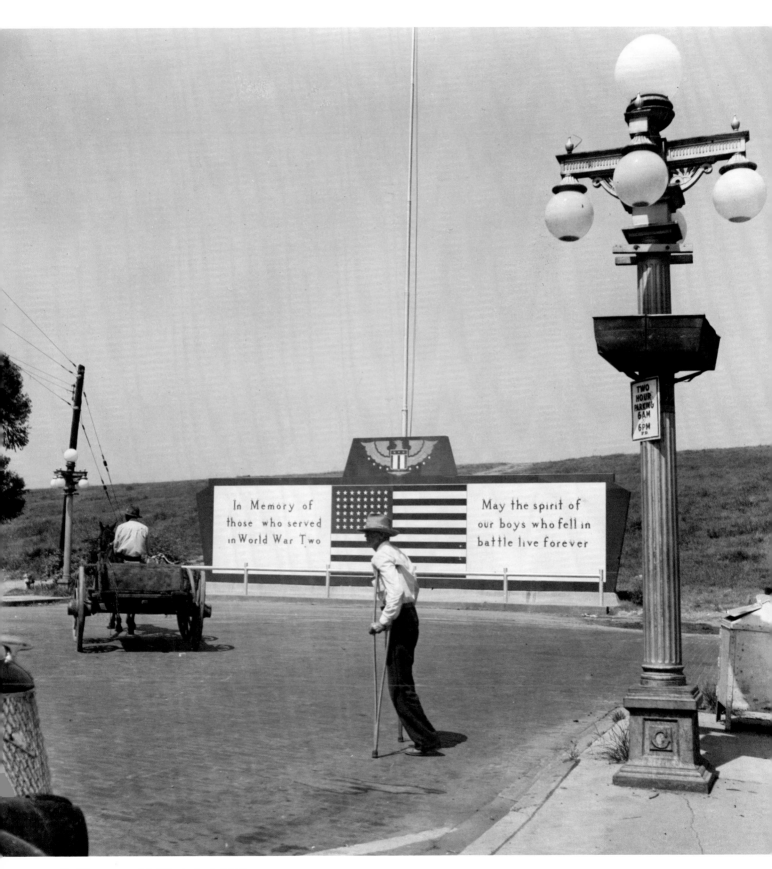

77. War memorial, Mississippi, 1947

The memorial text reads: "In Memory of those who served in World War Two" and "May the spirit of our boys who fell in battle live forever"

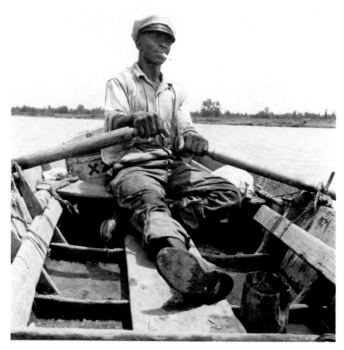

75. Fisherman, Louisiana, 1947

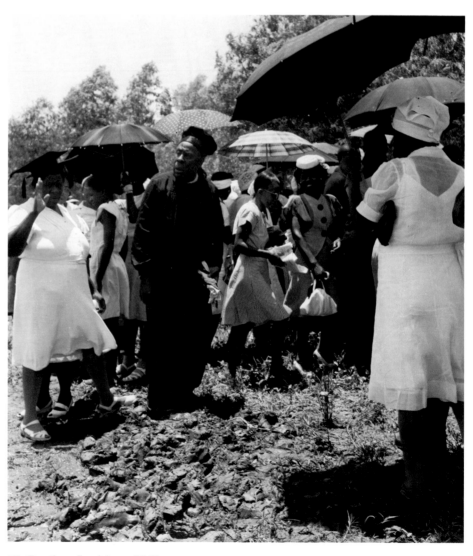

76. Baptism, Louisiana, 1947

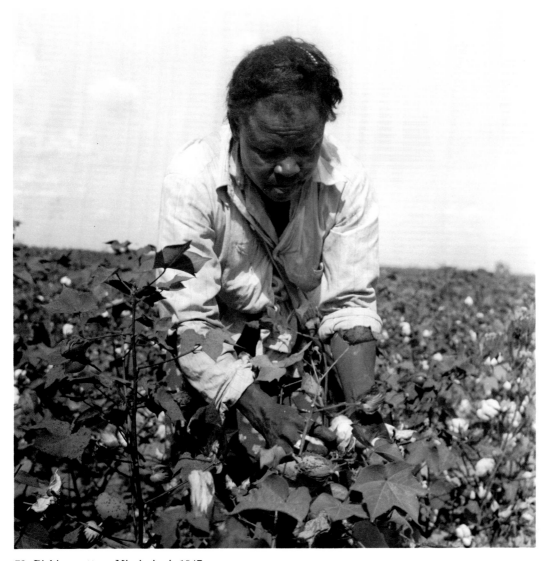

72. Picking cotton, Mississippi, 1947

73. Mechanical picker, Mississippi, 1947

74. Cotton wagon, Mississippi, 1947

Martha McMillan Roberts

Martha McMillan Roberts made nearly one thousand photographs for the Standard Oil project between 1946 and 1949. Virtually all of her assignments were done in the South, from the sweltering sugarcane fields of Louisiana to the small cotton farms of South Carolina.

Roberts was raised in Knoxville, Tennessee. In 1938, after completing one year at the University of Tennessee, she transferred to Black Mountain College, a small experimental undergraduate school in North Carolina. At Black Mountain she studied painting under Josef Albers, the geometric abstractionist who had taught at the Bauhaus. Albers loaned her his Leica camera, and she began to photograph regularly.

After two intense years at Black Mountain, Roberts moved on to Washington, D.C., to work as an apprentice darkroom technician for Roy Stryker's FSA historical section. Besides developing film and making prints, Roberts became acquainted with several FSA photographers and their work. Stryker recommended news photography as the best way for her to gain shooting experience. She worked as a news photographer in the Washington bureau of the *Chicago Sun* and later for Acme Newsservice. Before long, the deadlines, crowds, and constant jostling for position with other news photographers sent her looking for the opportunity to do more thorough assignments. She soon went to work for the War Food Administration (WFA), taking photographs of farmers in the South.

In 1946, shortly after the WFA expired, Roberts went to see Roy Stryker about obtaining an assignment from Standard Oil. Knowing that Roberts had become a versatile photographer familiar with much of the South, Stryker assigned her to the bayous of Louisiana. Roberts photographed Cajun shrimpers and oystermen at Grand Isle. As a woman photographer from New York, she was looked upon with a rather high degree of suspicion. Eventually, though, the shrimpers warmed up to her and she managed to complete a fine "picture story" on the Gulf shrimp industry around Grand Isle. As Roberts said, Stryker "knew that wherever he sent me, I could get along."

In 1947, Roberts was particularly busy in the South. Near Clarksdale, Mississippi, she visited a cotton farm where International Harvester tested its cotton harvesters. Her portrait of a woman practicing the back-breaking travail of picking cotton by hand (Plate 72) offers a striking contrast to her photograph of a gasoline-powered mechanical picker (Plate 73) and suggests the impact such mechanization would have on migration out of the Deep South. Along the Mississippi River at Point Breeze, Louisiana, Roberts did a "picture story" on a fisherman-farmer named Horace Johnson who made a living rowing his boat out into the Mississippi River to barter his vegetables and river shrimp for sugar and lard with the crews of passing Standard Oil tankers (Plate 75).

In late 1948 Roberts began her last assignment for Roy Stryker at Standard Oil, concentrating on the small cotton farmers of South Carolina (Plate 78). Her work near Aiken demonstrated the sensitivity and humility which characterized her approach to her subjects.

After leaving Standard Oil, Roberts moved to Washington, D.C. There she taught photography at the Institute of Contemporary Arts. She had a major exhibition at Catholic University which included some of her Standard Oil work. In the early 1960's, her book *Public Gardens and Arboretums of the United States* was published. As a consultant to the Kennedy administration's Commission on Youth, she photographed children and teenagers in New York City and Washington, D.C., and migrant children on the eastern shore of Maryland. Later, as a freelance photographer living in New York City, she did assignments for the United Mine Workers Union, the AFL-CIO, the Southern Regional Council, and the Fred Lavanburg Foundation. Her work was published in such magazines as *The Lamp*, *Fortune*, and *Woman's Day*. Roberts now resides in Westport, Connecticut.

ca. 1946. Courtesy Martha McMillan Roberts.

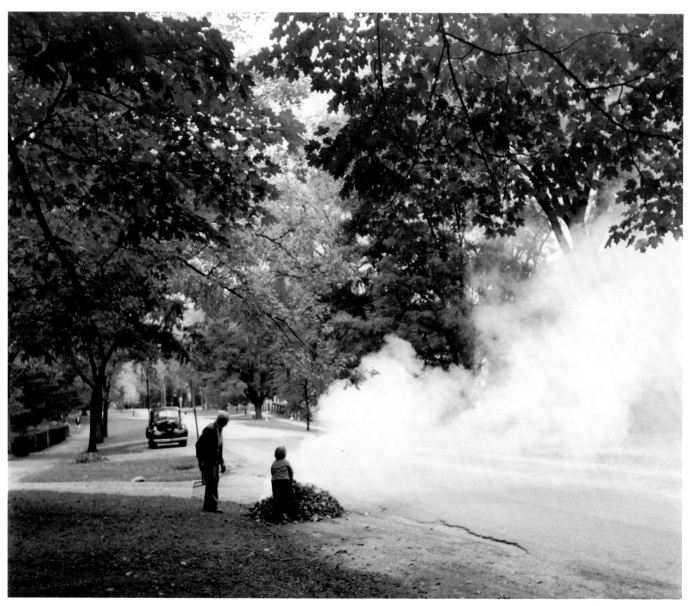

71. Burning leaves, Massachusetts, 1946

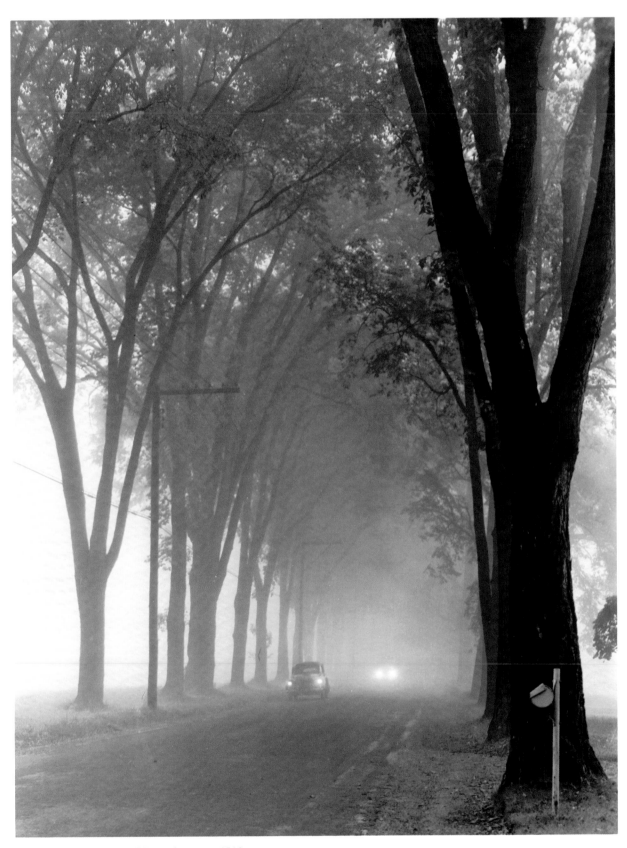

70. Early morning fog, Massachusetts, 1946

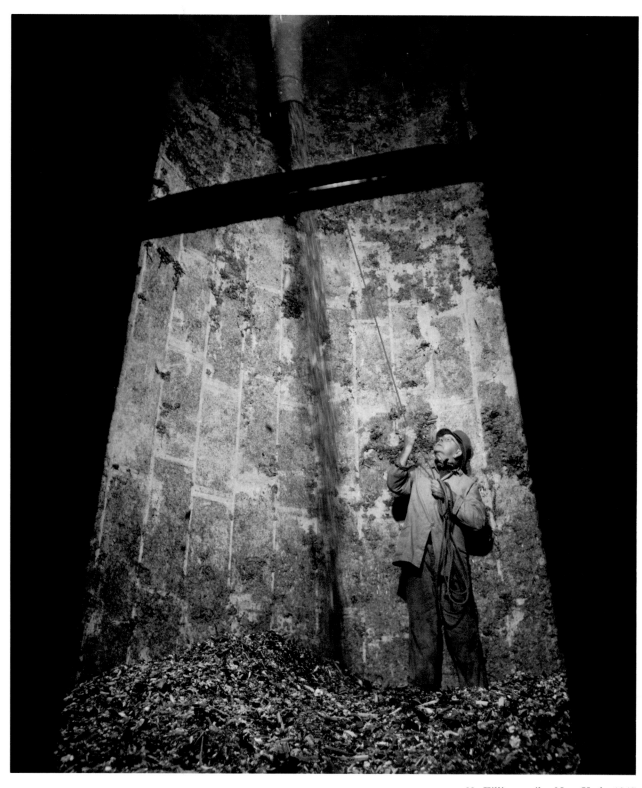

69. Filling a silo, New York, 1945

Todd Webb

Todd Webb produced hundreds of meticulously composed photographs for the Standard Oil project. Born in 1905, Webb worked in banking and export businesses for a time. He left Detroit, his home town, to prospect for gold in the Southwest and Central America.

Webb, who joined the Jersey Standard project in 1946, was influenced strongly by his teachers, Arthur Siegel and Ansel Adams, as well as by other photographers such as Alfred Stieglitz, Walker Evans, and Helen Levitt.[1] In the introduction to an exhibition catalog entitled *Todd Webb: Photographs* (1979), photographic historian Beaumont Newhall characterized Webb as "an historian with a camera." Webb, wrote Newhall,

photographs subjects that interest him. Not for the world of abstraction, where form dominates subject to the exclusion of any literal interpretation. He has been classified as a documentary photographer, but to me this is not accurate, although his photographs are undeniably documents. The documentary photographer is more sociologist than historian: he seeks with his camera to point out needs for improving social conditions. Todd records what moves him, what fascinates him: he photographs that which defines the character of a place.[2]

Throughout Todd Webb's Standard Oil work there is indeed a strong feeling for place. Webb's ability to capture the qualities of a particular locale may be seen in the nearly thirty images he made during a Standard Oil assignment in Pittsburgh in April 1948. Recalling the circumstances at the time of his Pittsburgh assignment, Webb said,

I think the industrial landscape can be wonderful to photograph . . . Pittsburgh was having a clean-up campaign. They were trying to make it a clean city at that time. I think I was really there to photograph the bad part, the way it was before the clean-up. I wasn't instructed to do it that way, but I knew that that was what I would do because that was the most impressive thing about Pittsburgh. The atmospheric quality of the pollution was really kind of wonderful for photography. I exploited that quite a bit.

In 1955, one of Webb's Pittsburgh photographs was included by Edward Steichen among the 503 images in the exhibition "The Family of Man."

Webb's use of large-format cameras dictated his "single image" rather than "picture story" style at Standard Oil. While photographing for the company, Webb generally used $4 \times 5''$ and $5 \times 7''$ cameras with "slow" lenses. He wrote in 1947,

At present I am shooting with an old-fashioned view camera and a very slow lens. If people seem conspicuous by their absence in my pictures, that is the reason, although pictures without people sometimes tell a stronger story.[3]

Due to the inherent technical limitations of the view camera, the presence of humanity in Webb's photographs is often implicit rather than explicit; in much of his work Webb used "symbols of people rather than people [themselves]."

I believe that most of the things I liked to photograph . . . were not of people exactly, but things that people have either done to the landscape, or things that represent the efforts of people. What man has done to the landscape is much more important to me than the landscape itself. Just having people in the picture doesn't make it human for me.

Webb's photographs of a highway billboard (Plate 87) and a Louisiana fruit market (Plate 88) demonstrate his fascination with "things that represent the efforts of people."

In 1949, after contributing more than three thousand photographs to Standard Oil's files, Webb moved to France, where he lived until 1953, when he returned to the United States. During the late 1940's and the 1950's, he did assignments for *Fortune, Life, Ladies' Home Journal,* and *Collier's* as well as for the United Nations, the World Bank, and the World Health Organization. He was awarded Guggenheim Fellowships in 1955 and 1956 to retrace and photograph the pioneer trails to Oregon and California. He sold his photograph collection to a New York dealer in the mid-1970's.

1. Todd Webb, *Todd Webb: Photographs,* unpaged.
2. Ibid.
3. Todd Webb, "Finest Photographs," in *U.S. Camera Annual 1947,* ed. Tom Maloney, p. 247.

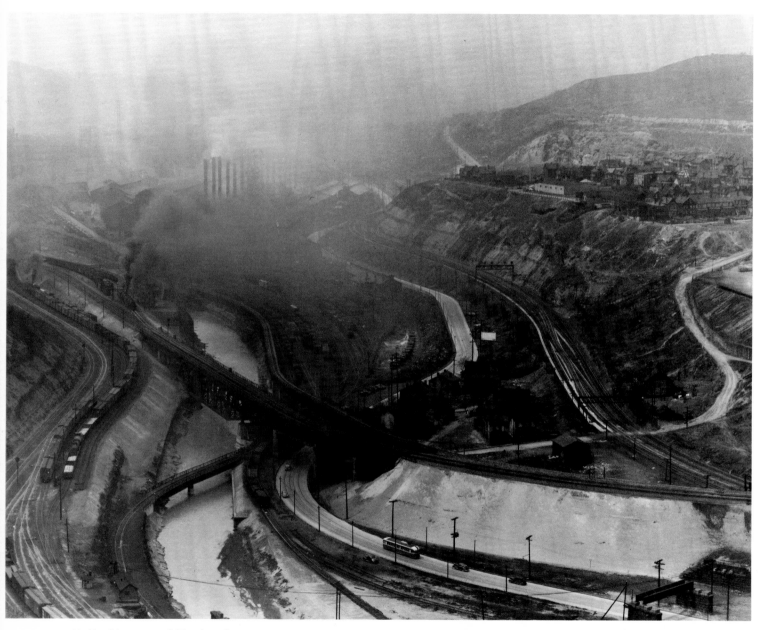

83. Looking toward Pittsburgh, 1948

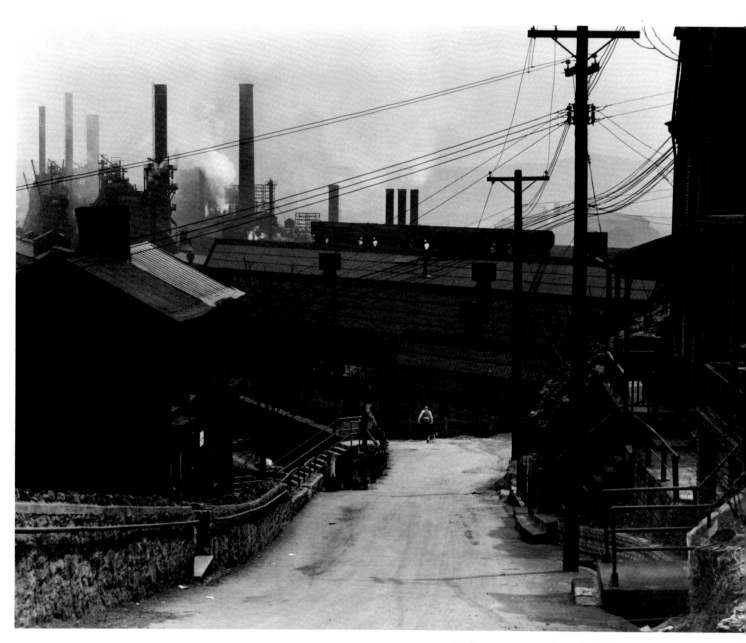

84. Street scene and steel mill, Pittsburgh, 1948

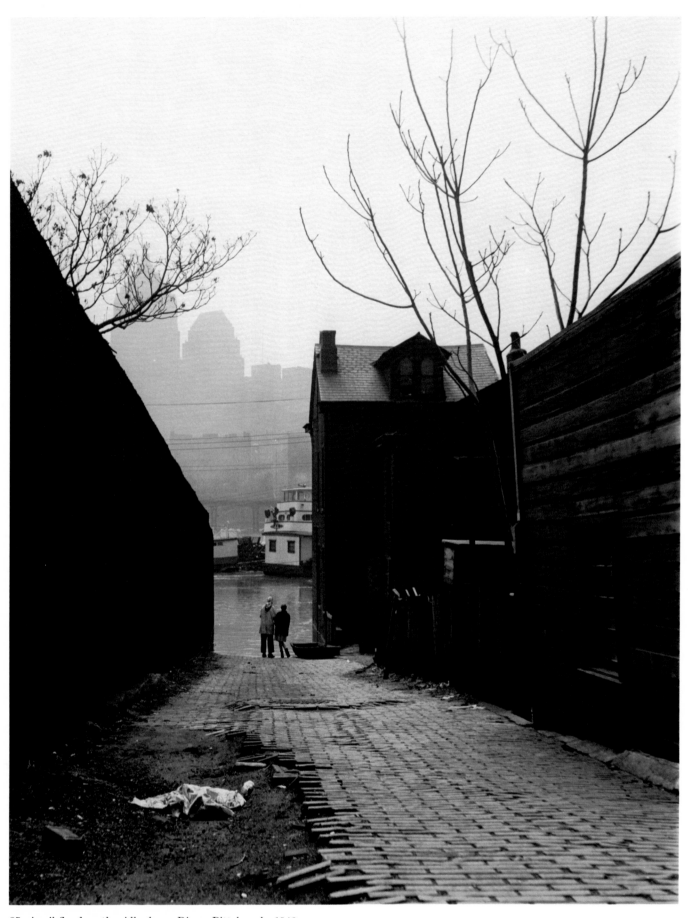

85. April flood on the Allegheny River, Pittsburgh, 1948

86. Signaling an airline pilot, Pittsburgh, 1948

87. Along Highway 61, near St. Francisville, Louisiana, 1947

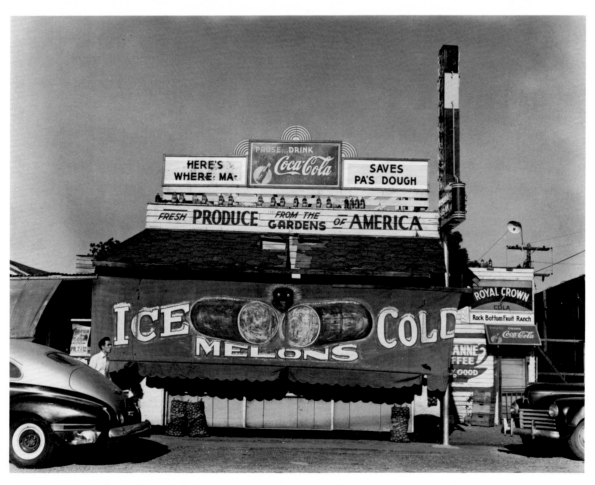

88. Fruit market, Baton Rouge, 1947

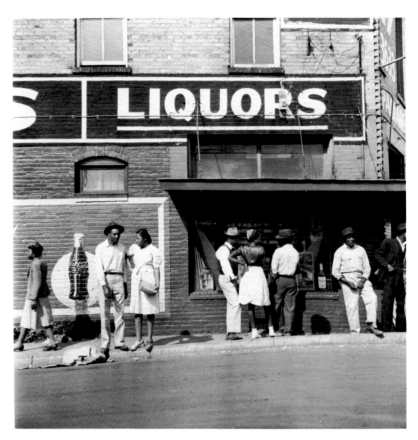

89. Saturday morning at 6th and Main, Monroe, Louisiana, 1947

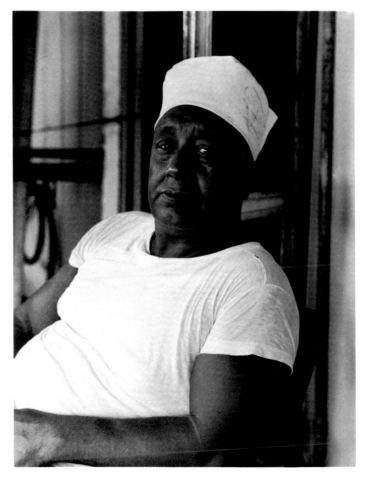

90. Towboat cook, Mississippi River, 1947

1977. Photograph by J. Jalapeeno.

Russell Lee

In 1947, after a separation of nearly four and one-half years, Roy Stryker invited former FSA photographer Russell Lee to take an assignment for Standard Oil. After leaving the Office of War Information in 1943, Lee had risen to the rank of major in the Air Transport Command. His extremely detailed aerial photographs of unfamiliar terrain were used to prepare military pilots for their hazardous missions. Following a brief postwar respite spent in Texas and Colorado, in 1946 Lee served as the staff photographer for an extensive survey of health and living conditions experienced by America's bituminous coal miners.[1]

One of Lee's earliest trips for Standard Oil took him to the bayous of Louisiana, where he recorded the work of "swamp shooters," company seismographic crews searching for oil. Recalling his strenuous trip through the bayous, Lee said,

We went up the bayou on a party boat and stayed there overnight. In the morning, we went out with the crew. I remember wearing tennis shoes and old pants. A 35 mm camera was all I carried, thank god. I was out there two, maybe three days with them, just slogging along in the mud up to your knees.

Lee's "picture story" called "The Swamp Shooters" proved to be enormously popular; it was carried by seventeen independent newspapers and magazines and by two hundred newspapers served by the King Features syndicate. Stryker estimated that more than 8.5 million people viewed "The Swamp Shooters."[2]

Working much as he had for the FSA, making "pictures of most of the country and the towns and anything I thought was pertinent to an area," in 1947 Lee took a wide variety of photographs throughout the state of Texas, including Mexican-American beet packers in the Lower Rio Grande Valley (Plate 98), a horse race in central Texas (Plate 94), and the wide-open oilfields near Midland in West Texas (Plate 91).

Trained at Lehigh University as a chemical engineer, Lee was especially capable of understanding and interpreting the complexity of the petroleum business.

I knew something about catalytic cracking. There were these big spheroids for storage. Why they were spheroids, I don't know. Or tanks, same way. That was great. You just looked for your best viewpoint. You had plenty of time. The time of day—if you thought it was better to come back at 4 o'clock to photograph, you came back and photographed.

While Lee's interest in depicting the unintended beauty in oil operations is evident in much of his Standard Oil work, he concentrated, nevertheless, on the human element—itinerant wheat harvesters, farmers, and others who produced and used oil.

Lee accepted freelance assignments from time to time after Stryker left Standard Oil. From 1965 to 1973, he taught photography at the University of Texas at Austin. He has lived in Austin since 1947.

1. F. Jack Hurley, *Russell Lee, Photographer*, pp. 24–25.
2. Ibid., p. 26.

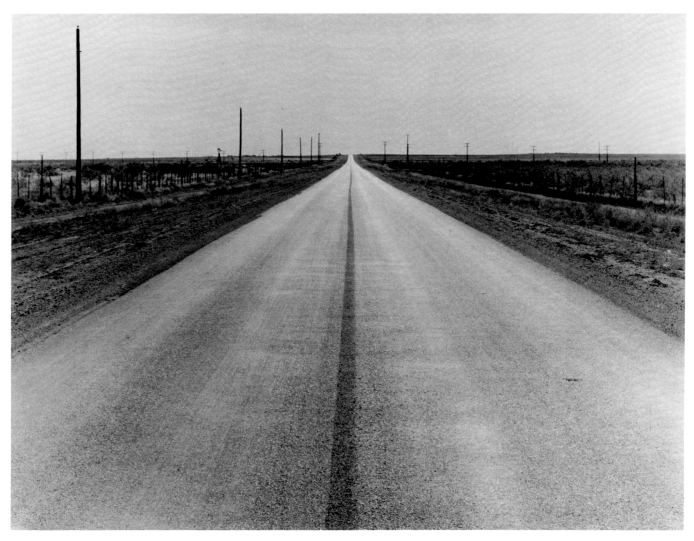

91. Highway east of Midland, Texas, 1947

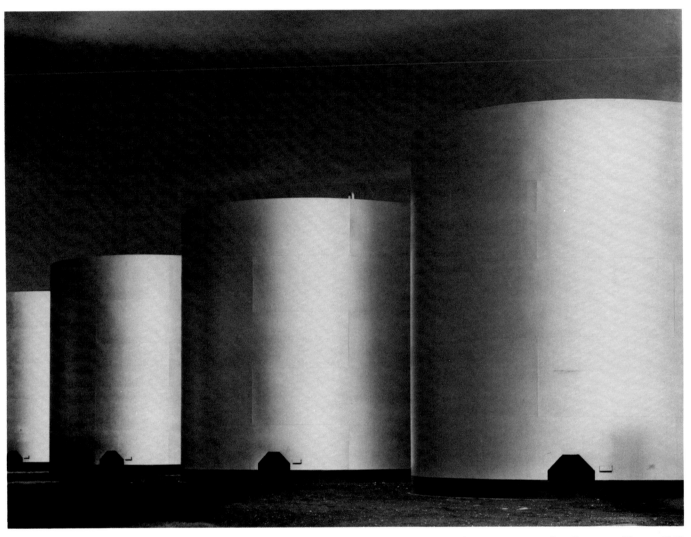

92. Refinery storage tanks, Baytown, Texas, 1949

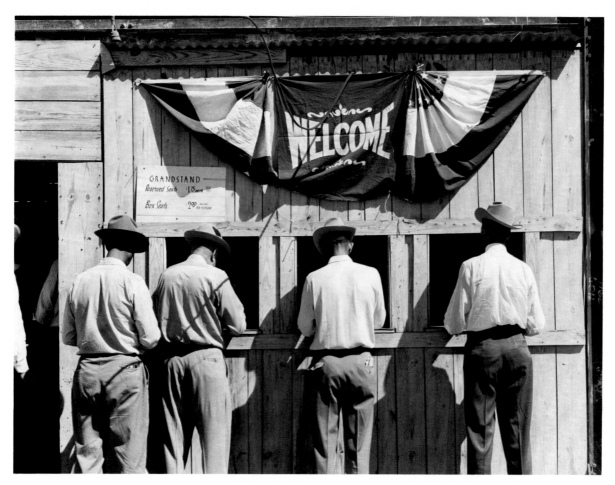

93. Ticket stand at rodeogrounds, San Angelo, Texas, 1947

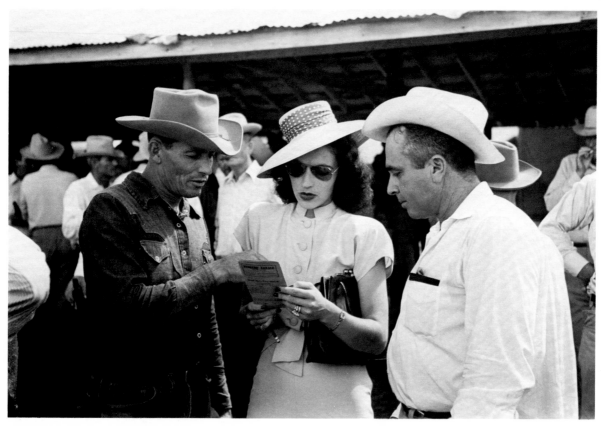

94. Horse race, Fredericksburg, Texas, 1947

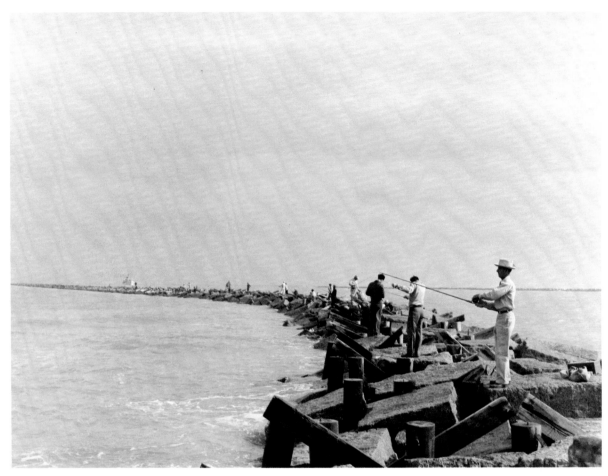

96. Gulf of Mexico, Port Isabel, Texas, 1947

95. Rancher, near Junction, Texas, 1950

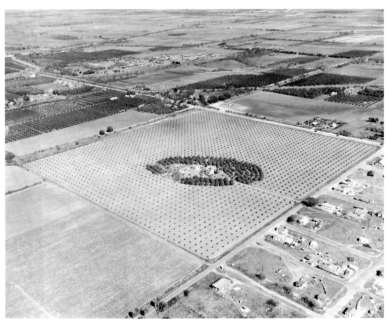

97. Citrus estate, near Weslaco, Texas, 1948

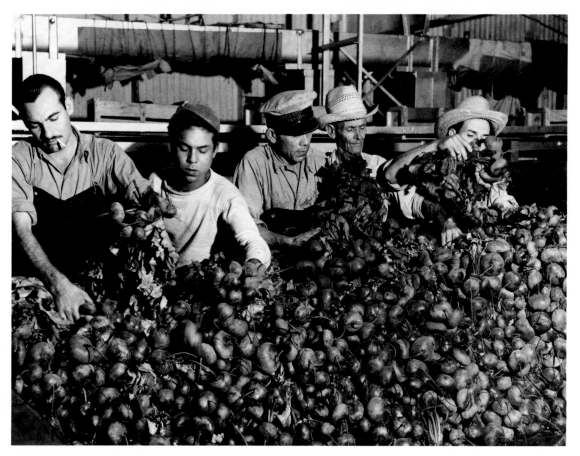

98. Sorting beets, Elsa, Texas, 1947

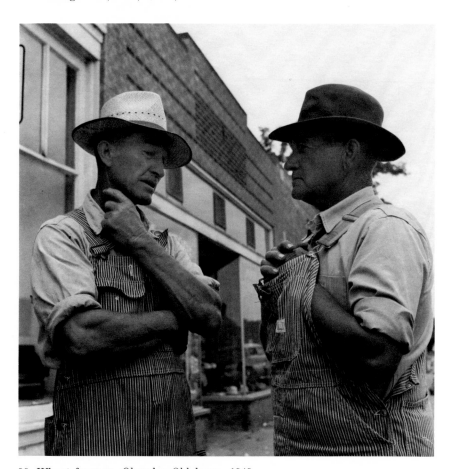

99. Wheat farmers, Okarche, Oklahoma, 1949

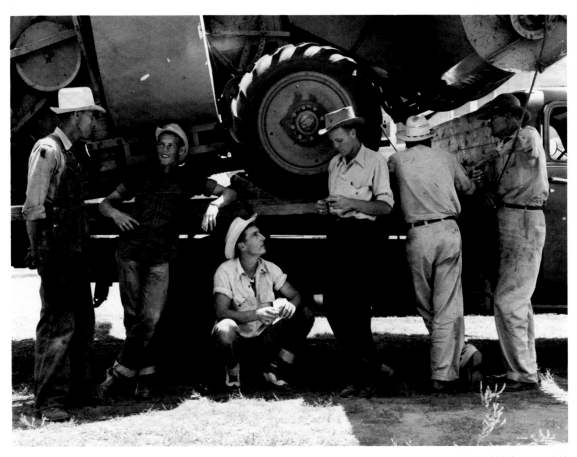

100. Itinerant combine crew, Frederick, Oklahoma, 1949

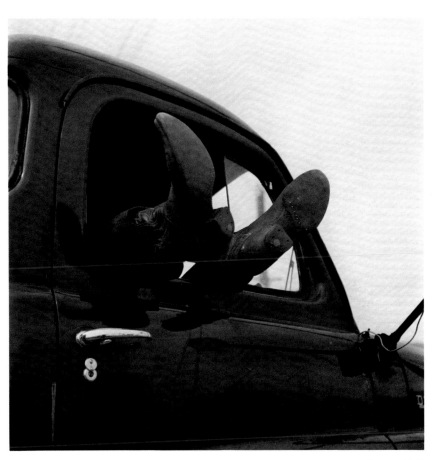

101. Sleeping truckdriver, Vernon, Texas, 1949

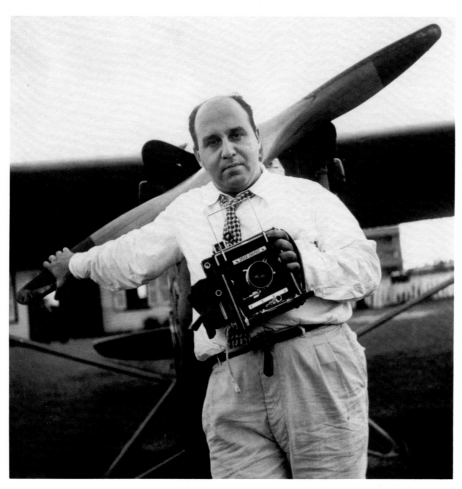

ca. 1945. Photo courtesy Charles Rotkin.

Charles Rotkin

Several Standard Oil photographers—including Todd Webb, Russell Lee, and John Collier—made stunning photographs from the air. No one, however, rivaled Charles Rotkin as an aerial photographer for Standard Oil.

The last major project photographer hired, Rotkin was a close personal friend of Edwin and Louise Rosskam. During the early 1940's, the Rosskams introduced Rotkin to Roy Stryker at the FSA historical section office in Washington. Soon thereafter, Rotkin was drafted and spent most of World War II as a photographer in Puerto Rico. While in Puerto Rico, Rotkin documented the island and its people in a style reminiscent of that practiced by many of the FSA photographers. His first book, *Puerto Rico: Caribbean Crossroads* (1947), showed the influence the FSA group had on his work.

In Puerto Rico, Rotkin pioneered a low-altitude aerial photography technique which typically utilized a specially adapted, handheld 4 × 5″ camera in a small plane flying at altitudes ranging from 250 to 1,000 feet above the ground. Looking for work on the mainland after the war, Rotkin sent samples of his airborne work to Stryker at Standard Oil. In November 1948, Stryker sent Rotkin into the skies aboard airplanes normally used to patrol pipelines owned and operated by Standard Oil and its affiliates. Several hundred feet above Oklahoma in November 1948, Rotkin made one of his best-known Standard Oil photographs, a view of a Rock Island railroad roundhouse near El Reno (Plate 104). Rotkin recalled,

I knew the points we'd be flying between ahead of time. What the hell was there, I didn't know. A lot of it was chance. But the point is, this was my function, to find what was visual.

As was usually the case, Rotkin was unable to pre-visualize his roundhouse photograph.

I hadn't even seen it before. It was early morning . . . I wasn't paying the slightest bit of attention . . . The pilot flew over the railroad line . . . We were shooting from the right side of the plane. I heard this crazy shrieking sound and I thought a wing was coming off the plane. And what happened was that these crazy guys below [in the locomotives] were blowing their whistles at us! We were low enough, and with the door open, the steam whistles really penetrated the sound of the airplane engine. That's when I realized what we had here. I said to the pilot, "Let's go around that roundhouse a couple of times."

As the pilot entered his circular pattern over the roundhouse, Rotkin concentrated on the viewfinder frame of his camera. "When I saw what I liked in the frame from a composition point of view," said Rotkin, "I fired."

In addition to his views of Oklahoma, Rotkin trained his cameras on New York, Pennsylvania, Louisiana, Mississippi, and other states. Whenever possible, he also photographed people and places on the ground. Although he was just as versatile on land as in the air, Stryker preferred to keep Rotkin airborne as often as possible.

Rotkin's work quickly attracted notice. "Low-Flight Landscape," a *Fortune Magazine* article devoted exclusively to Rotkin's aerial photographs, praised the images as being "singularly satisfying in the fresh perspective that is neither majestic airliner panorama nor the tourist's familiar glimpse through his windshield."[1]

Like many of his Standard Oil colleagues, Rotkin turned to commercial and industrial freelance work for magazines and other clients after leaving Standard Oil. Besides operating his own small midtown-Manhattan firm, Photography for Industry, Rotkin has published three books since the end of the Jersey Standard project: *Europe, An Aerial Close-up* (1962), *The U.S.A., An Aerial Close-up* (1968), and *Professional Photographer's Survival Guide* (1982).

1. "Low-Flight Landscape," *Fortune*, April 1949, p. 103.

102. Clover-leaf intersection, New Jersey, 1949

103. Residential area, Pennsylvania, 1949

104. Roundhouse, Oklahoma, 1948

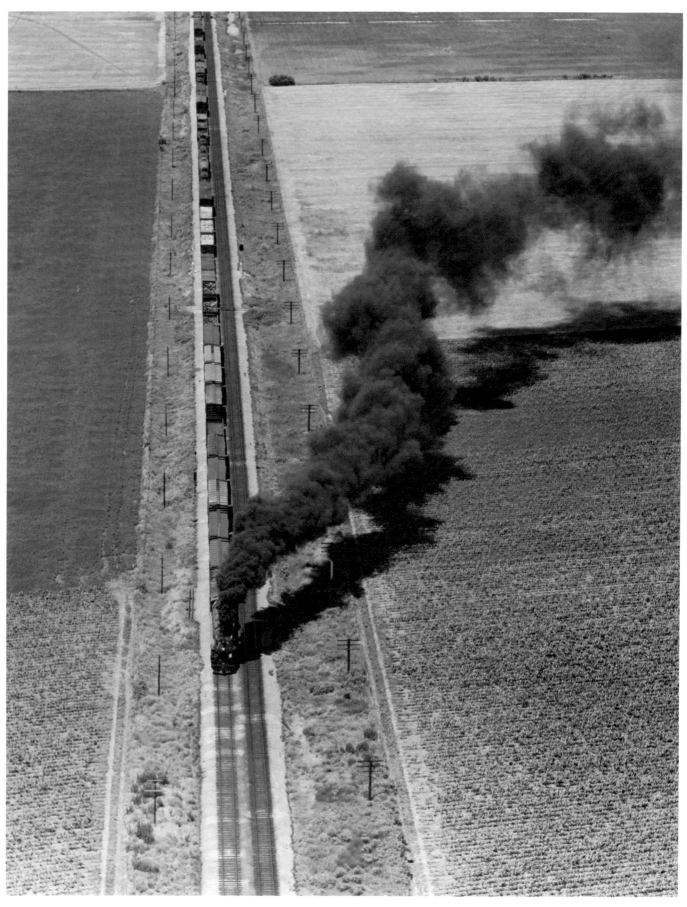

105. Freight train, Kansas, 1949

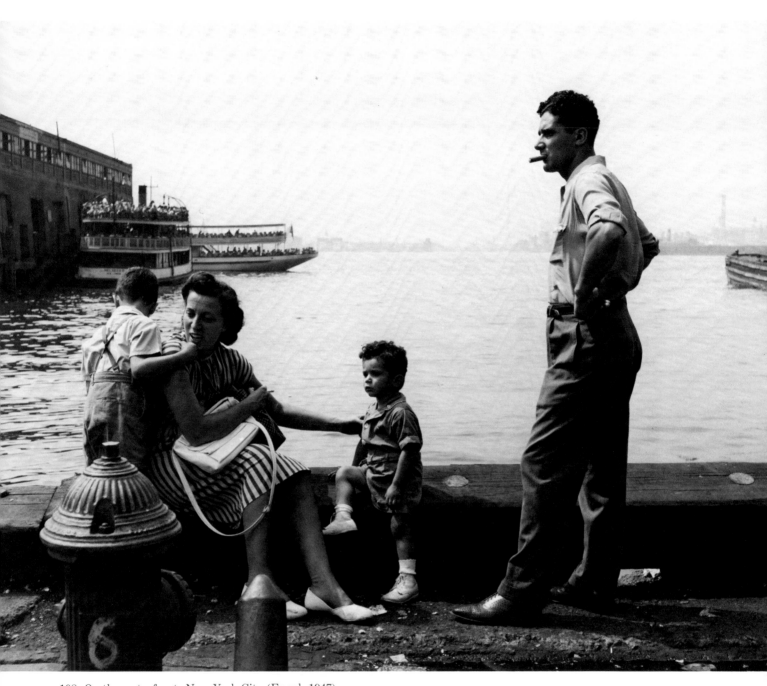

108. On the waterfront, New York City (Engel, 1947)

Single Images

106. Watering horses, Mississippi, 1948

107. Cemetery and housing project, New Orleans, 1948

110. Well in the center
of an oil camp, Illinois
(Corsini, 1944)

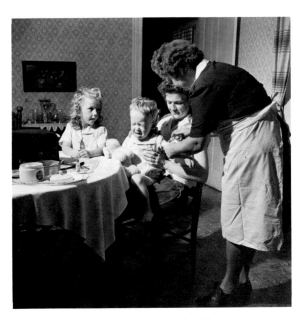

109. Nurse giving a shot, North Carolina
(Libsohn, 1945)

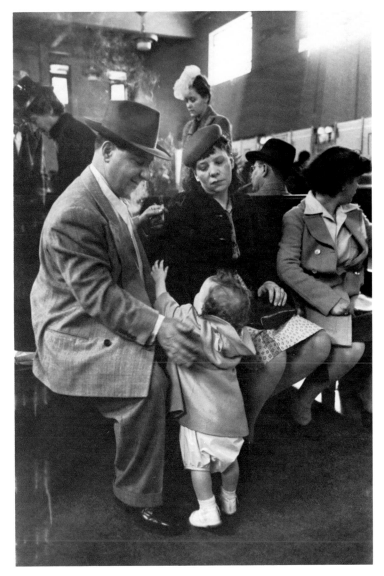

111. Bus terminal, New York City
(Bubley, 1947)

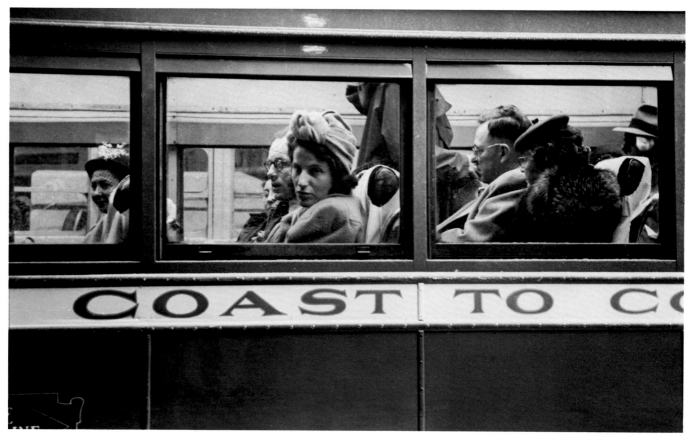

112. Leaving the bus terminal, New York City (Bubley, 1947)

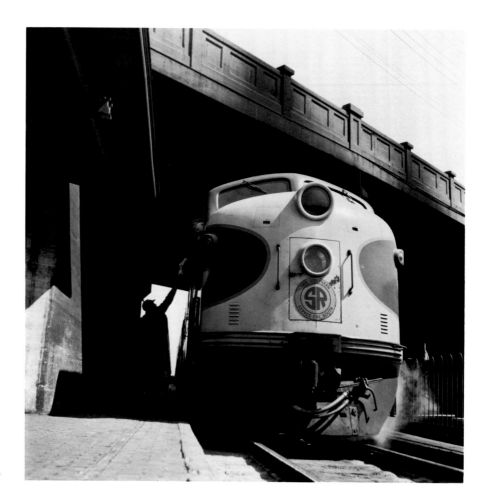

113. Engineer receiving orders,
 Virginia (Libsohn, 1947)

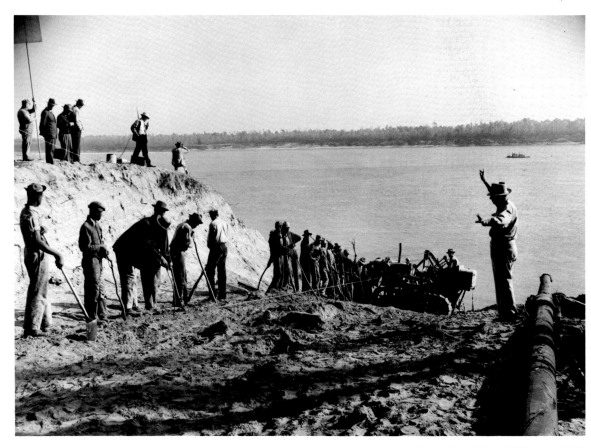

114. Laying pipeline across the Mississippi River (Libsohn, 1944)

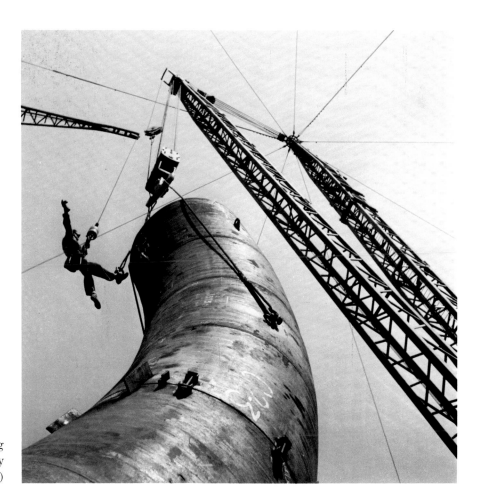

115. Iron worker rigging
a section of standpipe, New Jersey
(Libsohn, 1948)

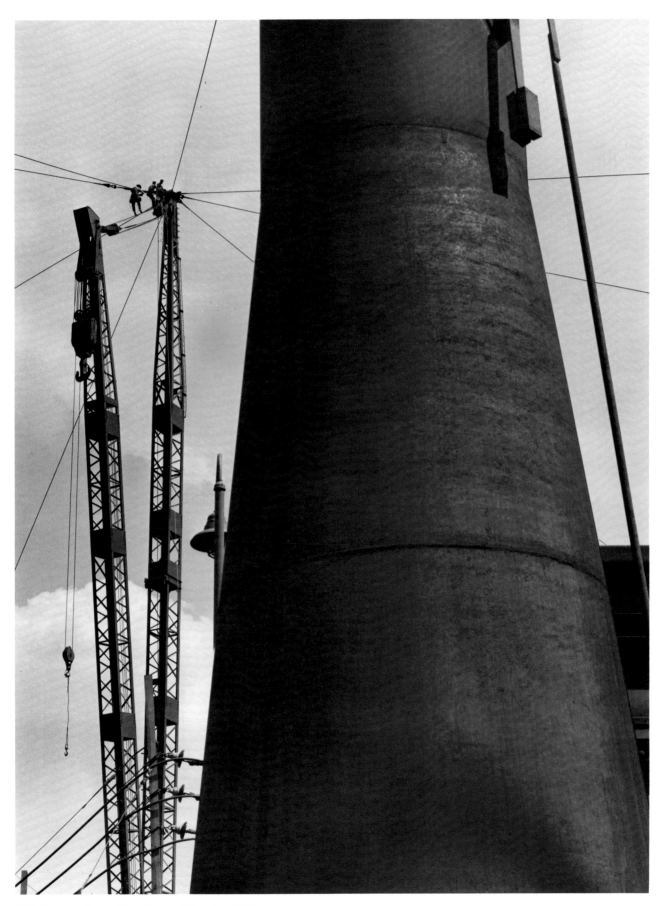

116. Iron workers, New Jersey (Libsohn, 1948)

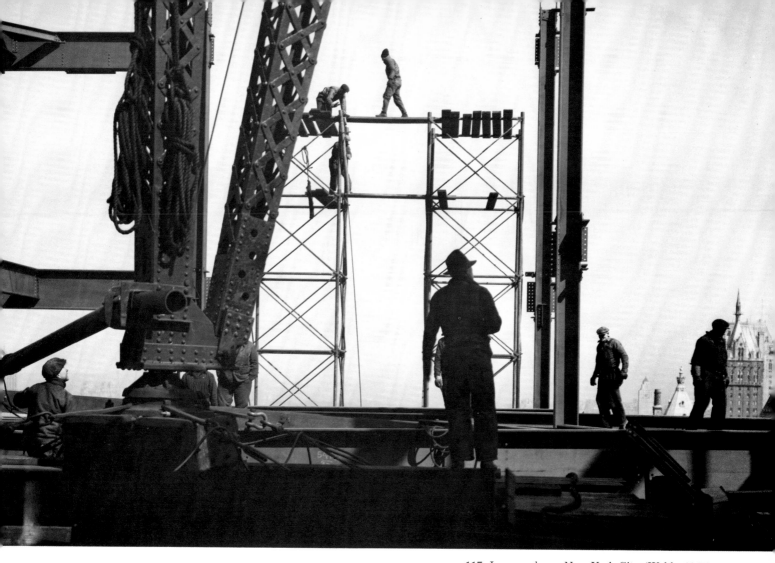

117. Iron workers, New York City (Webb, 1947)

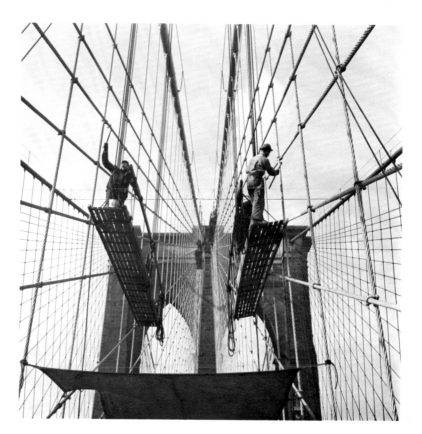

118. Painters on the Brooklyn Bridge,
New York City (Bubley, 1946)

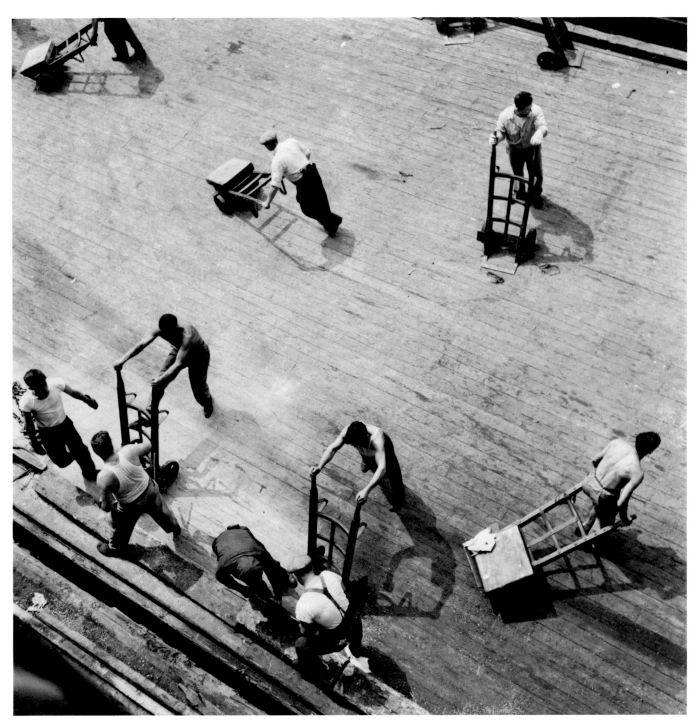

119. Loading copper ingots, New York City (Engel, 1947)

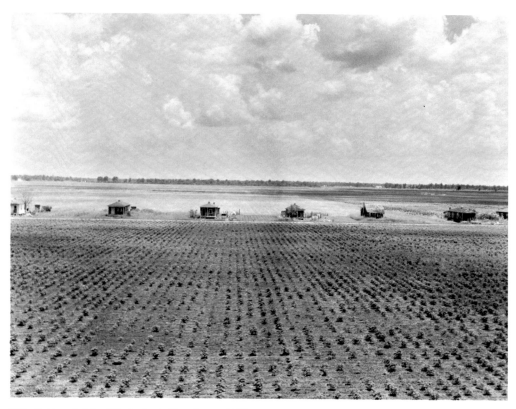

126. Cotton fields, Mississippi (Rosskam, 1946)

127. Barnyard, Illinois (Lee, 1947)

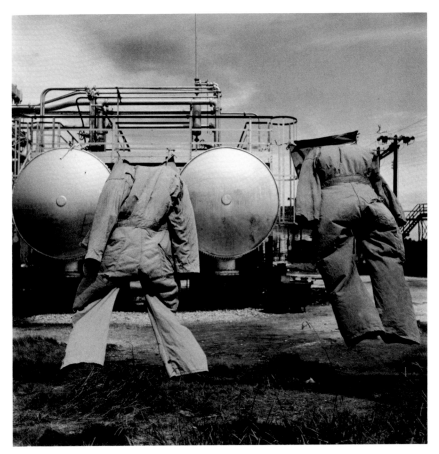

124. Overalls drying, Texas (Corsini, 1946)

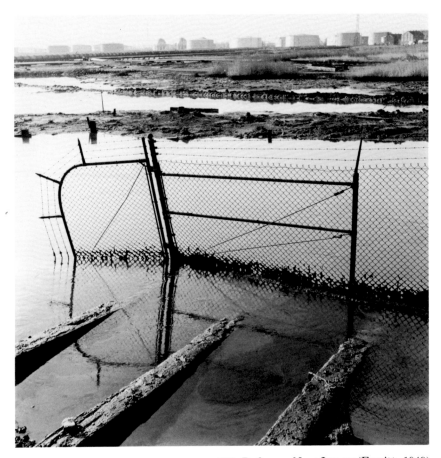

125. Refinery, New Jersey (Erwitt, 1949)

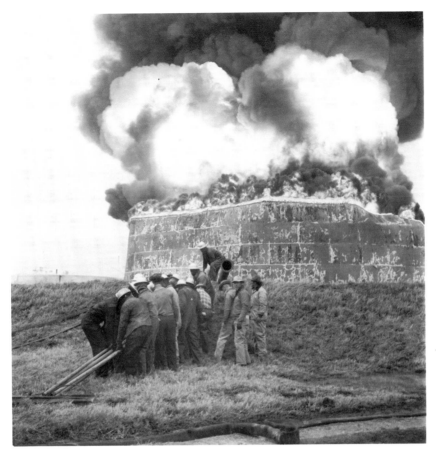

122. Burning naphtha tank, Louisiana (Webb, 1948)

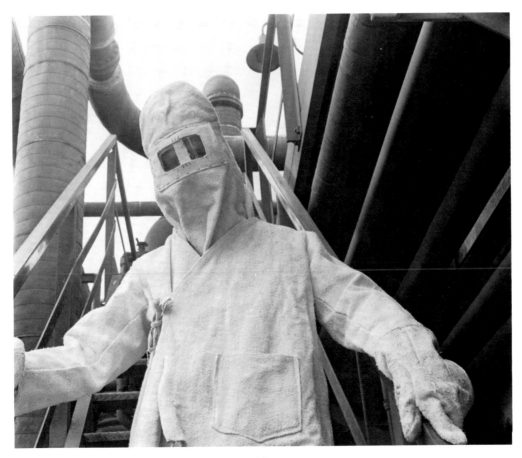

123. Asbestos safety suit, Texas (Rosskam, 1944)

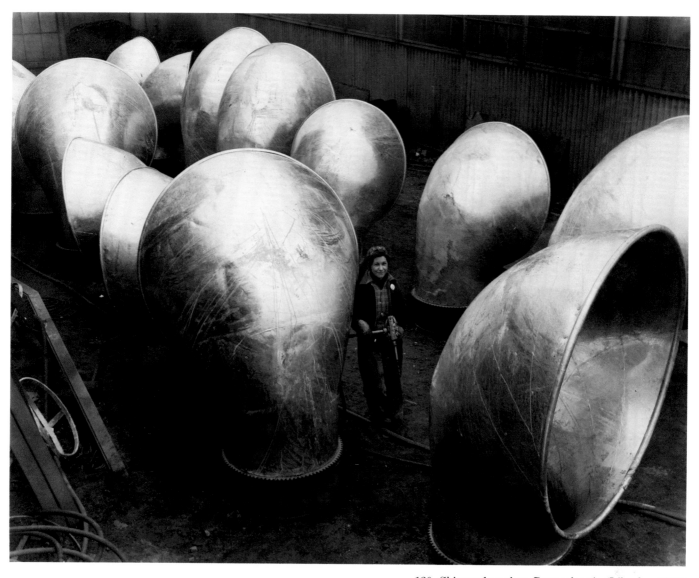

120. Shipyard worker, Pennsylvania (Libsohn, 1944)

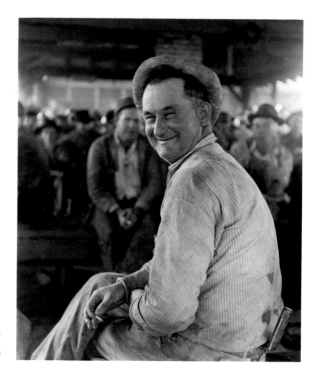

121. Relaxing in a refinery "smoking pen,"
Louisiana (Rosskam, 1943)

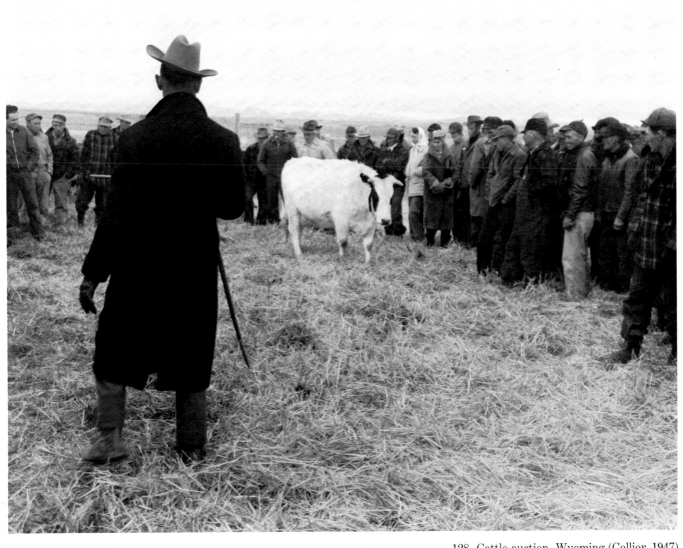

128. Cattle auction, Wyoming (Collier, 1947)

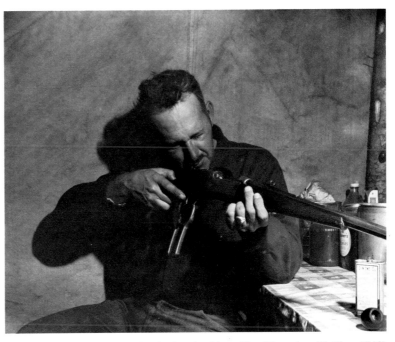

129. Geologist checking rifle, Wyoming (Collier, 1948)

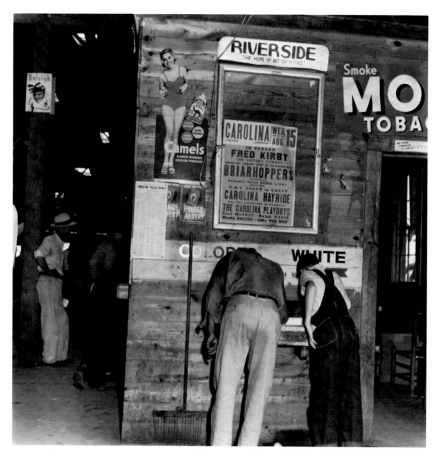

130. Tobacco warehouse, North Carolina (Bubley, 1946)

131. Wooden Indian, New York (Libsohn, 1945)

132. Acadian great-grandmother, Louisiana (Eagle, 1946)

133. Window shopping, New York City (Model, 1948)

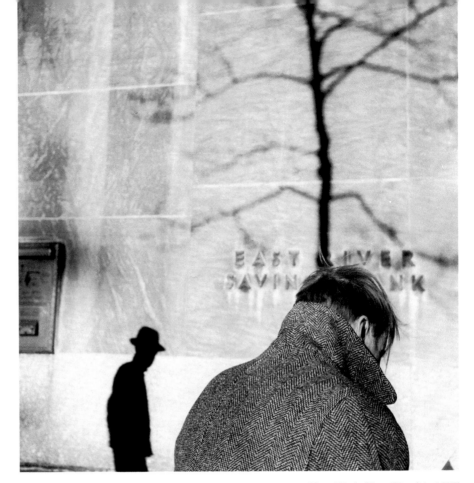

134. Rockefeller Center, New York City (Erwitt, 1950)

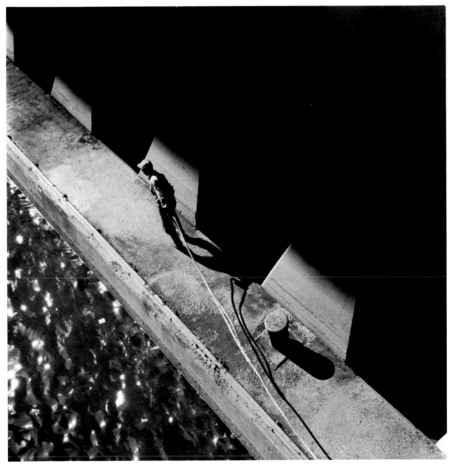

135. Iron ore dock, Wisconsin (Bubley, 1947)

Exhibition
Checklist

In 1981 the Exxon Corporation awarded the International Center of Photography (ICP) a grant to organize the first major retrospective exhibition of photographs from the Standard Oil Company (New Jersey) photographic project. Cornell Capa and I met at the University of Louisville Photographic Archives to plan the exhibition and to begin selecting its photographs. For the sake of cohesion, it was decided that the exhibition should include only black and white images made in the United States during the years Roy Stryker directed the Standard Oil photographic project. Over the course of a dozen trips to Louisville, I viewed all of the Archives' Standard Oil photograph albums and selected nearly 1,000 images for possible inclusion in the exhibition. Capa and I reduced the total to 190 photographs to be used in the exhibition. I then selected the 135 images in this volume.

In the list which follows, each photograph reproduced in this book is preceded by its plate number. Unless noted otherwise, all photographs were printed and cropped following the instructions written on the Standard Oil negative sleeves by the photographers themselves. Those prints marked with an asterisk were cropped differently from the photographers' original wishes due to technical flaws in the negatives.

Copies of Standard Oil photographs may be ordered at nominal cost from the Photographic Archives, University of Louisville, Louisville, Kentucky 40208. When ordering, please provide the full caption, negative number, and print size (8 × 10″, 11 × 14″, or 16 × 20″) for each photograph desired.

JOHN VACHON

Northern Plains, January 1948

1. A wheat farm in Ransom County, North Dakota. Neg. 54606.
2. Delivering mail along State Route 1, Ransom County, North Dakota. Neg. 54605.
3. Gas station during a snowstorm, Wheaton, Minnesota. Neg. 54805.
☐ Main Street during a snowstorm, Wheaton, Minnesota. Neg. 54807.
4. Gravedigger, Edmore, North Dakota. Neg. 54785.

Landscapes

5. Beehive coke ovens along U.S. 60 near Boomer, West Virginia, October 1947. Neg. 52581.
6. Hub cap display on U.S. 1 near Jersey City, New Jersey, July 1947. Neg. 48558.
7. Automobile junkyard, Clarksburg, West Virginia, October 1947. Neg. 52682.
8. Tunnel worker resting during lunch hour, New York City, July 1948. Neg. 49148.
9. Under a viaduct, Bethlehem, Pennsylvania, November 1947. Neg. 53880.
☐ Outerbridge Crossing, Perth Amboy, New Jersey, September 1947. Neg. 50854.
10. Front porches of rowhouses, Allentown, Pennsylvania, December 1947. Neg. 53974.
11. Opera house on Main Street, Shepherdstown, West Virginia, October 1947. Neg. 52507.

HAROLD CORSINI

Oilfield Life

12. Street scene, Cushing, Oklahoma, May 1946. Neg. 37320.
13. An old resident, Cushing, Oklahoma, May 1946. Neg. 37342.
14. Shoe repair shop, Cushing, Oklahoma, May 1946. Neg. 37323*.
15. Service station owner, Cushing, Oklahoma, May 1946. Neg. 37301.
16. Fire department personnel, Cushing, Oklahoma, May 1946. Neg. 37249.
17. Farmers shopping on Saturday, Purcell, Oklahoma, May 1946. Neg. 34175.
☐ Mail boxes along a state highway, McClain County, Oklahoma, April 1946. Neg. 34004.
18. Coiling a rope on an oil derrick, McClain County, Oklahoma, April 1946. Neg. 34703.
☐ Derrick builder climbing braces, McClain County, Oklahoma, April 1946. Neg. 34795.
☐ Bolts used in building derricks, McClain County, Oklahoma, April 1946. Neg. 34805.
☐ Wire rope used to support traveling block, McClain County, Oklahoma, May 1946. Neg. 37555.
☐ Finished male tool joints, Tulsa, Oklahoma, March 1946. Neg. 38597.
19. Driller seen from beneath drilling floor, McClain County, Oklahoma, May 1946. Neg. 37535.
20. "Rigging up" crew preparing to go home, McClain County, Oklahoma, May 1946. Neg. 34162.
21. Hands of a driller's helper, Union County, Kentucky, September 1944. Neg. 14028.

Towboat Life

22. On the riverfront, St. Louis, Missouri, June 1945. Neg. 25567.

23. A sternwheeler bound downstream passes a diesel-powered towboat on the Mississippi River near Natchez, Mississippi, June 1945. Neg. 25982.

24. The officers' mess aboard the towboat *Jack Rathbone*. From left to right: the pilot, second engineer, and first mate. On the Mississippi River, December 1943. Neg. 1528.

25. Card game in the crew lounge, on the Ohio River, May 1945. Neg. 24510.

26. Lockman stands in front of bulletin board bearing the latest river news for passing boat crews, on the Ohio River, May 1945. Neg. 24738.

☐ Mate of the steamer *Sam Craig*, Pittsburgh, Pennsylvania, May 1945. Neg. 23521.

☐ A veteran porter in a boat supply store. Behind him are kerosene and electric lanterns. St. Louis, Missouri, June 1945. Neg. 25563.

Northwestern Oil Towns, 1944

27. Oil train crossing the prairie between Cut Bank and Browning, Montana, August 1944. Neg. 13009.*

28. In Joe's Bar, Cut Bank, Montana, August 1944. Neg. 13080.

29. Hotel restaurant frequented by oil men, Cody, Wyoming, July 1944. Neg. 12084.

30. Amateur radio night in a park featuring the "Catskinner from Elk Basin" and his daughter singing a cowboy number, Powell, Wyoming, July 1944. Neg. 12201.

31. Washing the car in an oil camp, Elk Basin, Wyoming, July 1944. Neg. 12144.

32. Children and pets of oilfield families, Elk Basin, Wyoming, July 1944. Neg. 12133.

☐ Trailer camp established under government auspices and open only to war workers, inhabited largely by oil and pipeline workers, Cody, Wyoming, June 1944. Neg. 12086.

☐ Feed store which also sells fishing and hunting equipment and supplies to oil men, Powell, Wyoming, June 1944. Neg. 7950.

Rural Texas, 1945

33. Men listening to a speech by the school superintendent at a public prayer meeting on VE Day, Tomball, Texas, May 1945. Neg. 24369.

☐ Tomball's city commissioners and mayor (center) in the town hall, Tomball, Texas, May 1945. Neg. 25099.

34. The City Cafe, Tomball, Texas, May 1945. Neg. 25134.

35. Playing "moon," a domino game, in the town pool hall, Tomball, Texas, April 1945. Neg. 26232.

☐ Waiting for the day's mail in the post office, Tomball, Texas, May 1945. Neg. 24357.

☐ Barber applying a few finishing touches to a customer, Tomball, Texas, May 1945. Neg. 24704.

36. Mixed quartet singing during evening prayer service in the Baptist Church, Tomball, Texas, May 1945. Neg. 25178.

37. Child about to be immersed during baptismal service, Tomball, Texas, May 1945. Neg. 25175.

38. Selling berries along a road between Houston and Tomball, Texas, April 1945. Neg. 26247.

39. Feed store, Tomball, Texas, May 1945. Neg. 26191.

40. Main Street, Andrews, Texas, July 1945. Neg. 27263.

41. Drug store conversation, Andrews, Texas, July 1945. Neg. 27361.

42. Oilfield family at home in their tent. A son plays the guitar while his father and brothers listen. Andrews, Texas, July 1945. Neg. 27235.

43. Oilfield roustabout with two of his eight children, Andrews, Texas, July 1945. Neg. 27238.

44. The top of a boy's dresser, Bandera County, Texas, July 1945. Neg. 26510.

45. Rodeo spectator, Utopia, Uvalde County, Texas, July 1945. Neg. 26477.

☐ A hat rack in a ranch house, near Dryden, Terrell County, Texas, September 1945. Neg. 30955.

New England

46. Dinner time, Sommerville, Maine, February 1944. Neg. 2696.

47. Main Street scene, Springfield, Massachusetts, February 1945. Neg. 22789.

48. Farmhouse, Rochester, Vermont, October 1947. Neg. 52849.

49. Farmers spreading field with hydrated lime, Hancock, Vermont, October 1947. Neg. 52868.

☐ Jamaican tobacco workers returning to their living quarters after a day of work in the fields, West Suffield, Connecticut, May 1945. Neg. 23727.

Portraits

☐ Tobacco and vegetable farmer with his wife and grandson, South Deerfield, Massachusetts, October 1947. Neg. 52810.

50. Farmer, Skowhegan, Maine, August 1944. Neg. 15369.
51. Farm couple, Skowhegan, Maine, August 1944. Neg. 15368.
□ Owner of a general store who also runs the town snow plow in winter, acts as postmaster, and manages his own farm, Sommerville, Maine, January 1944. Neg. 1649.
52. In the "coopers' plant" of the Pittsburgh Grease Plant, where large drums and containers are reconditioned, a workman lifts a drum from a solution of boiling lye which has cleared it of grease and dirt particles. Pittsburgh, Pennsylvania, March 1944. Neg. 3124.
53. An eighty-seven-year-old portrait photographer who has been in business in the same location for 65 years, Cooperstown, New York, August 1946. Neg. 41266.
54. Early morning commuters aboard the Staten Island Ferry, New York City, New York, November 1946. Neg. 43422*.

SOL LIBSOHN

Trucking Story, 1945

55. Trucker driving at night, U.S. 22, Pennsylvania, May 1945. Neg. 23653.
56. Refueling on the Pennsylvania Turnpike, Bedford, Pennsylvania, May 1945. Neg. 25225.
57. Lunch counter in the Trylon Diner, Clinton, New Jersey, May 1945. Neg. 23610.
58. Trucker unwinds after finishing his run from Long Island to Akron. Akron, Ohio, March 1945. Neg. 22987.
59. Counter in a restaurant, Darlington, Pennsylvania, May 1945. Neg. 25346.

60. Truckers waking up to begin another day on the Pennsylvania Turnpike, Bedford, Pennsylvania, May 1945. Neg. 25396.

Leisure

61. Soldier home on furlough talks with friends in front of a general store, Brown Summit, North Carolina, May 1944. Neg. 8374.
62. Residents of Hatteras gather at a local store to discuss politics, religion, and fishing. Two of the fishermen are dressed in their Sunday best after attending a church revival across the street earlier in the evening. Hatteras, North Carolina, June 1945. Neg. 26767.
63. Sons of a local Standard Oil Company worker fast asleep just before breakfast, Bayou Sale District, Louisiana, September 1944. Neg. 15847.
64. Circus elephants wearing clown heads before the grand parade, Philadelphia, Pennsylvania, May 1946. Neg. 34576.
65. Motorcycle show barker making his pitch at the New Jersey State Fair, Trenton, New Jersey, September 1947. Neg. 53752.
66. Circus midget "Major Mite—Poland's Smallest Man" proudly displays identification card showing he was employed in defense industries during the war. Philadelphia, Pennsylvania, May 1946. Neg. 34516.
□ Resting after strenuous sight-seeing at the New Jersey State Fair, Trenton, New Jersey, September 1947. Neg. 53554 M-3.
67. Farmers relaxing at an inn, Shartlesville, Pennsylvania, May 1945. Neg. 23677.

CHARLOTTE BROOKS

The Rural Northeast

68. Signs of autumn in a farm cellar, Stormville, New York, November 1945. Neg. 30645.
69. Farmer controlling a blower inside a silo, Kanona, New York, September 1945. Neg. 33929.
□ Farmer bringing calf to market, Bath, New York, September 1945. Neg. 33925.
□ Gravestones, New London, Connecticut, September 1946. Neg. 42083.
□ Stowe, Vermont, February 1946. Neg. 33574.
70. Early morning fog, Williamstown, Massachusetts, October 1946. Neg. 42401.
□ Early morning fog, Williamstown, Massachusetts, October 1946. Neg. 42406.
71. Burning leaves, Stockbridge, Massachusetts, October 1946. Neg. 42808.

MARTHA McMILLAN ROBERTS

The Deep South

72. Picking cotton by hand on an old plantation near Arcola, Mississippi, September 1947. Neg. 53214.
73. Mechanical cotton picker near Clarksdale, Mississippi, October 1947. Neg. 53271.
74. Cotton wagon parked at a gin, Tribbett, Mississippi, September 1947. Neg. 53207.
75. A Mississippi River fisherman in his rowboat, Point Breeze, Louisiana, July 1947. Neg. 52391.
□ Mississippi River fisherman coming home after a day's work in his cotton patch, Point Breeze, Louisiana, July 1947. Neg. 52388.

76. Baptist minister speaking to some of his congregation after a baptismal service in the Mississippi River near Garyville, Louisiana, July 1947. Neg. 49581.

77. World War II memorial at the end of Main Street in front of the Mississippi River levee, Greenville, Mississippi, September 1947. Neg. 53199.

78. A resident of Aiken, South Carolina, November 1948. Neg. 63169.

79. An eighty-six-year-old Acadian woman on the front porch of her home on the Bayou Terrebonne, near Houma, Louisiana, August 1947. Neg. 50735.

80. On a slow day for business, a blacksmith sits in the window of his shop and plays the accordion, near Houma, Louisiana, August 1947. Neg. 52422.

81. Yard man at a sugar co-op, New Iberia, Louisiana, November 1946. Neg. 43632.

☐ A cotton picker who has worked in the fields for sixty-four years, Arcola, Mississippi, September 1947. Neg. 53215.

82. Substitutes watch a high school football game from the sidelines, Friar's Point, Mississippi, October 1947. Neg. 53258.

TODD WEBB

Pittsburgh

83. Looking toward Pittsburgh, Pennsylvania, April 1948. Neg. 59452.

84. Looking down Bates Street toward the Jones and Laughlin steel mill, Pittsburgh, Pennsylvania, April 1948. Neg. 59352.

☐ Houses from the Bloomfield Bridge, Pittsburgh, Pennsylvania, April 1948. Neg. 59338.

☐ Jones and Laughlin steel workers relaxing at lunch, Pittsburgh, Pennsylvania, April 1948. Neg. 59266.

85. Springtime flood on the Allegheny River, Pittsburgh, Pennsylvania, April 1948. Neg. 59320.

86. Giving parking instructions to a pilot at Allegheny County Airport, Pittsburgh, Pennsylvania, April 1948. Neg. 59313.

Louisiana

87. Roadside billboard advertising an antebellum plantation mansion near St. Francisville, Louisiana, May 1947. Neg. 48997.

☐ Graveyard adjoining an Episcopal church, St. Francisville, Louisiana, July 1947. Neg. 49336.

☐ Paddlewheels of *The Sprague* and *The Slack Barrett*, Baton Rouge, Louisiana, April 1947. Neg. 48132.

88. Fruit market, Baton Rouge, Louisiana, May 1947. Neg. 48912.

89. Saturday morning at 6th and Main, Monroe, Louisiana, May 1947. Neg. 48948.

90. The cook on the towboat *The Sprague*, Baton Rouge, Louisiana, June 1947. Neg. 49739.

RUSSELL LEE

Texas

91. State Highway 158, West Texas, east of Midland, October 1947. Neg. 53519.

92. Storage tanks north of the methyl ethyl ketone unit at Baytown Refinery, Baytown, Texas, February 1949. Neg. 63300.

93. Buying tickets at the West Texas Race Meet and Exposition, San Angelo, Texas, September 1947. Neg. 53462.

94. Comparing notes on horses running in the next race, Gillespie County Fair, Fredericksburg, Texas, August 1947. Neg. 52296 M-8.

95. The stirrup, boot, and spur of a rancher, near Junction, Texas, March 1950. Neg. 67197.

96. Salt water fishermen on a jetty in the Gulf of Mexico, Port Isabel, Texas, December 1947. Neg. 57154.

97. Aerial view of an estate surrounded by citrus trees north of Weslaco, Texas, January 1948. Neg. 57267.

98. Packinghouse workers sorting beets, Elsa, Texas, December 1947. Neg. 57118.

☐ Crowd waiting for citrus festival parade to begin, Mission, Texas, January 1948. Neg. 57315.

Itinerant Wheat Harvesters, 1949

☐ Combine operators eat breakfast in their dining trailer at 5:45 A.M., near Vernon, Texas, June 1949. Neg. 64057.

99. Wheat farmers converse in an Oklahoma town, Okarche, Oklahoma, June 1949. Neg. 64161.

100. Members of an itinerant combine crew, Frederick, Oklahoma, June 1949. Neg. 64198.

101. Truck driver asleep in the cab of his truck, Vernon, Texas, June 1949. Neg. 64123.

CHARLES ROTKIN

Low-Flight Landscapes

102. Clover-leaf intersection west of the George Washington Bridge, Paramus, New Jersey, August 1949. Neg. 64963.

□ Financial district viewed from easterly side of the Battery, New York City, New York, April 1949. Neg. 63674.

□ Catalytic cracking towers and cooling units of the Standard Oil refinery, Baton Rouge, Louisiana, November 1948. Neg. 61422.

103. Residential area near Clairton, Pennsylvania, April 1949. Neg. 63595.

104. Rock Island Railroad roundhouse, El Reno, Oklahoma, November 1948. Neg. 61849.

105. Union Pacific freight train running through the wheat country east of Lawrence, Kansas, June 1949. Neg. 64481.

□ Small tow on the Mississippi River, near Plaquemine, Louisiana, November 1948. Neg. 62178.

106. Farmer watering horses, Liberty, Mississippi, November 1948. Neg. 61936.

□ A plowed wheat field, near Happy, Texas, April 1950. Neg. 67359.

107. An old cemetery adjacent to a public housing project near the French Quarter, New Orleans, Louisiana, October 1948. Neg. 61703.

SINGLE IMAGES

108. A family outing on the waterfront, New York City, New York. Photograph by Morris Engel. August 1947. Neg. 50382.

□ Preacher in front of his church, Baton Rouge, Louisiana. Photograph by Edwin and Louise Rosskam. December 1943. Neg. 900.

109. A mother holds her son as a public health nurse administers a diphtheria vaccination, Hatteras, North Carolina. Photograph by Sol Libsohn. June 1945. Neg. 26691.

□ Nurse taking a baby's measurements at a clinic, Elizabeth, New Jersey. Photograph by Esther Bubley. April 1944. Neg. 5925.

□ Standard Oil employees exercising in a "keep fit" class, Elizabeth, New Jersey. Photograph by Esther Bubley. April 1944. Neg. 5827.

□ Children of an oilfield roughneck listen to the radio, Andrews, Texas. Photograph by Esther Bubley. July 1945. Neg. 27231.

110. A well situated in the center of an oil camp, Fayette County, Illinois. Photograph by Harold Corsini. August 1944. Neg. 13483.

111. Waiting room in the Greyhound Bus Terminal, New York City, New York. Photograph by Esther Bubley. July 1947. Neg. 49538 M-13.

112. Loaded bus ready to depart the Greyhound Bus Terminal, New York City, New York. Photograph by Esther Bubley. July 1947. Neg. 49541 M-5*.

□ Bus passengers in the Greyhound Terminal, New York City, New York. Photograph by Esther Bubley. April 1947. Neg. 47298 M-14.

□ Clock shop in the French Quarter, New Orleans, Louisiana. Photograph by Todd Webb. January 1948. Neg. 54870.

□ Selling homemade wooden articles, near Lebanon, New Jersey. Photograph by John Vachon. July 1947. Neg. 48555.

□ Pausing on South Street, New York City, New York. Photograph by Esther Bubley. October 1946. Neg. 42697.

□ Southern Railway dispatcher's office, Spencer, North Carolina. Photograph by Sol Libsohn. March 1947. Neg. 45893.

113. Fireman hands orders to an engineer, Charlottesville, Virginia. Photograph by Sol Libsohn. March 1947. Neg. 45932.

114. Laying a pipeline across the Mississippi River near Natchez, Mississippi. Photograph by Sol Libsohn. November 1944. Neg. 16255*.

115. Iron worker rigging a fifty-ton section of standpipe before it is set into place in a fluid catalytic cracking unit at Bayway Refinery, Linden, New Jersey. Photograph by Sol Libsohn. September 1948. Neg. 60472.

116. Iron workers atop a guy derrick adjust one of the lines. Bayway Refinery, Linden, New Jersey. Photograph by Sol Libsohn. July 1948. Neg. 59931.

□ Iron worker helps guide a fifty-ton section of standpipe before it is set into place in a fluid catalytic cracking unit at Bayway Refinery, Linden, New Jersey. Photograph by Sol Libsohn. September 1948. Neg. 60471.

117. Iron workers on the 32nd floor of the new Standard Oil Company (New Jersey) Building, New York City, New York. Photograph by Todd Webb. March 1947. Neg. 36739.

118. Painters on the Brooklyn Bridge, New York City, New York. Photograph by Esther Bubley. November 1946. Neg. 43316.

119. Loading copper ingots on lighters, New York City, New York. Photograph by Morris Engel. August 1947. Neg. 52151.

□ Welder joins a pipe during construction of a refinery, Billings, Montana. Photograph by Harold Corsini. June 1949. Neg. 64748.

- Billboard on U.S. 22 near Irwin, Pennsylvania. Photograph by Sol Libsohn. May 1945. Neg. 25220.
120. Wartime shipyard worker in the stockyard where ventilators are finished, Chester, Pennsylvania. Photograph by Sol Libsohn. April 1944. Neg. 8626.
121. Refinery workers taking a break in a "smoking pen," the only area in which smoking is allowed in the Baton Rouge refinery, Baton Rouge, Louisiana. Photograph by Edwin and Louise Rosskam. November 1943. Neg. 488.
122. Firefighting crew hauling equipment to extinguish a blaze in a naphtha tank, Baton Rouge, Louisiana. Photograph by Todd Webb. January 1948. Neg. 57327.
123. Refinery worker wearing an asbestos suit for protection from heat, Baytown, Texas. Photograph by Edwin and Louise Rosskam. January 1944. Neg. 2146.
124. Refinery workmen's overalls hung on a line to dry, Baytown, Texas. Photograph by Harold Corsini. June 1946. Neg. 37832.
- China door knob on church, Hawkinstown, Virginia. Photograph by Todd Webb. November 1948. Neg. 62401.
- Close-up of a live oak tree stump, Louisiana. Photograph by Todd Webb. July 1947. Neg. 49493.
- Ice floating in the Ohio River, near Pt. Pleasant, West Virginia. Photograph by Todd Webb. February 1947. Neg. 44954.
- Close-up of cobblestone street after a rain, Portland, Maine. Photograph by Todd Webb. January 1947. Neg. 44252.

- Control lines on the roof of a control house which lead to various units of a refinery, Baytown, Texas. Photograph by Sol Libsohn. October 1946. Neg. 42723.
125. The swampy extremity of Bayway Refinery, with a "tank farm" in distance, Linden, New Jersey. Photograph by Elliott Erwitt. December 1949. Neg. 66388.
- Landscape near Linville, North Carolina. Photograph by Todd Webb. November 1948. Neg. 62471.
126. Delta cotton fields and pickers' homes near the Mississippi River, near Greenville, Mississippi. Photograph by Edwin and Louise Rosskam. July 1946. Neg. 39432.
127. Barnyard scene near Chenoa, Illinois. Photograph by Russell Lee. October 1947. Neg. 54337.
- Bank entrance, Bloomington, Illinois. Photograph by Russell Lee. October 1947. Neg. 54290.
- A Mormon sheep herder tending his flocks, near Grays Lake, Idaho. Photograph by John Collier. November 1948. Neg. 63065.
128. Auctioning a milk cow on a ranch in the Wind River Valley, Fremont County, Wyoming. Photograph by John Collier. December 1947. Neg. 57578.
129. A geologist checking his rifle before leaving for a hunting trip, Togwotee Pass, Wyoming. Photograph by John Collier. November 1948. Neg. 63031*.
130. Drinking fountains in tobacco warehouse, Lumberton, North Carolina. Photograph by Esther Bubley. August 1946. Neg. 41044.
131. Wooden cigar store Indian, Salamanca, New York. Photograph by Sol Libsohn. August 1945. Neg. 30536.

132. An Acadian great-grandmother who counts her direct descendants in the hundreds, Bayou Pierre Part, Louisiana. Photograph by Arnold Eagle. October 1946. Neg. 44757.
133. Window shopping on Fifth Avenue, Rockefeller Center, New York City, New York. Photograph by Lisette Model. April 1948. Neg. 56546.
134. Man in front of bank at Rockefeller Center, New York City, New York. Photograph by Elliott Erwitt. January 1950. Neg. 66658.
135. Crew member of a Great Lakes freighter handling a mooring line as the vessel moves in to dock, Superior, Wisconsin. Photograph by Esther Bubley. October 1947. Neg. 54208.

Selected Bibliography

COLLECTIONS

Standard Oil Company (New Jersey) Collection, Photographic Archives, University of Louisville, Louisville, Kentucky. Consisting of nearly 85,000 items, this collection includes the negatives, file prints, photograph albums, color transparencies, and captions created during Stryker's direction of the Jersey Standard project.

Standard Oil Company (New Jersey) Corporate Records, Exxon Corporation, New York City. Exxon, successor to Standard Oil Company (N.J.), possesses the lone set of 48 oversized volumes of contact prints of all project photographs in rough chronological order.

Standard Oil Company (New Jersey) Photograph Collection, Prints and Photographs Division, Library of Congress, Washington, D.C. Donated by the company in 1949, this is a small selection of approximately 400 photographs of Jersey Standard's worldwide operations.

Roy Stryker Collection, Photographic Archives, University of Louisville, Louisville, Kentucky. This collection of Stryker's personal papers and photographs concerns Stryker's direction of several documentary photography projects, including those done for the Farm Security Administration, Standard Oil, and the Jones and Laughlin Steel Corporation.

INTERVIEWS

Adams, Anne. Interview by S. W. Plattner, Bronxville, N.Y., 26 January 1980. University of Louisville Photographic Archives. Untranscribed.

Brooks, Charlotte. Interview by S. W. Plattner, Holmes, N.Y., 10 November 1980. University of Louisville Photographic Archives. Untranscribed.

Bubley, Esther. Interview by S. W. Plattner, Brooklyn, 30 March 1979. In possession of the author. Untranscribed. Restricted.

Corsini, Harold. Interview by S. W. Plattner, Pittsburgh, 21 July 1979. University of Louisville Photographic Archives. Transcribed.

Eagle, Arnold. Interview by S. W. Plattner, New York City, 29 June 1979. In possession of the author. Untranscribed. Restricted.

Forbes, Sally. Interview by S. W. Plattner, Brooklyn, 30 March 1979. University of Louisville Photographic Archives. Untranscribed. Restricted.

Freyermuth, George. Interview by Bennett Wall, San Francisco, 26 April 1976. In possession of the interviewer. Transcribed.

———. Interview by Bennett Wall, New York City, 18 and 19 December 1975. In possession of the interviewer. Transcribed.

Lee, Russell. Interview by S. W. Plattner, Austin, 11 April 1979. University of Louisville Photographic Archives. Transcribed.

Libsohn, Sol. Interview by S. W. Plattner, Roosevelt, N.J., 31 March 1979. University of Louisville Photographic Archives. Transcribed.

Maas, Carl. Interview by Bennett Wall, New York City, 1 August 1976. In possession of the interviewer. Transcribed.

Parks, Gordon. Interview by S. W. Plattner, New York City, 10 November 1979. University of Louisville Photographic Archives. Transcribed.

Roberts, Martha McMillan. Interview by S. W. Plattner, Westport, Conn., 22 August 1982. University of Louisville Photographic Archives. Untranscribed.

Rosskam, Edwin and Louise. Interview by S. W. Plattner, Roosevelt, N.J., 31 March 1979. University of Louisville Photographic Archives. Transcribed.

Rotkin, Charles. Interview by S. W. Plattner, New York City, 25 January 1980. University of Louisville Photographic Archives.

Sammis, Edward. Interview by S. W. Plattner, New York City, 9 November 1979. University of Louisville Photographic Archives. Untranscribed. Restricted.

Stanley, Edward. Interview by S. W. Plattner, New York City, 26 January 1980. University of Louisville Photographic Archives. Untranscribed.

Stryker, Roy. Interview by F. Jack Hurley, Montrose, Colo., 28 and 29 July 1967. Mississippi Valley Collection, Memphis State University Library. Transcribed.

———. Interview by Robert J. Doherty, F. Jack Hurley, J. M. Kloner, and Carl G. Ryant, Louisville, 14 April 1972. Oral History Center, History Department, University of Louisville. Transcribed.

Vachon, John. Interview by Richard K. Doud, New York City, 28 April 1964. Archives of American Art, Detroit. Transcribed. Restricted.

Webb, Todd. Interview by S. W. Plattner, Bath, Maine, 20 and 21 October 1979. University of Louisville Photographic Archives. Untranscribed.

BOOKS AND ARTICLES

Anderson, James C., ed. *Roy Stryker: The Humane Propagandist*. Louisville: University of Louisville Photographic Archives, 1977.

Brooks, Charlotte, illus. "Girl on Assignment." *Popular Photography*, February 1945, pp. 36–37, 94.

Bubley, Esther, illus. "Oil Town U.S.A: A Picture Story." *Coronet Magazine,* April 1946, pp. 99–117.

———. "Tobacco." *The Lamp,* January 1947, pp. 20–23.

———. "Town Portrait." *Minicam Photography,* December 1945, pp. 20–31.

———. "Via Bus." *The Lamp,* September 1949, pp. 19–23.

Corsini, Harold, illus. "Oil Powerhouse of the Eastern Hemisphere." *The Lamp,* January 1949, pp. 2–7.

Doherty, Robert J. *Social-Documentary Photography in the U.S.A.* Garden City, N.Y: Amphoto, 1976.

Hurley, F. Jack. *Industry and the Photographic Image.* New York: Dover, 1980.

———. *Portrait of a Decade.* Baton Rouge: Louisiana State University Press, 1972.

———. *Russell Lee, Photographer.* Dobbs Ferry, N.Y: Morgan & Morgan, 1978.

Kahan, Mitchell, ed. *Art, Inc.: American Paintings from Corporate Collections.* Montgomery: Montgomery Museum of Fine Arts, 1979.

Larson, Henrietta M., Evelyn H. Knowlton, and Charles S. Popple. *New Horizons, 1927–1950: History of Standard Oil Company (New Jersey).* New York: Harper & Row, 1971.

Lee, Russell, illus. "The Swamp Shooters." *The Lamp,* January 1948, pp. 8–13.

———. "The Valley." *The Lamp,* June 1948, pp. 6–11.

Libsohn, Sol, illus. "Building the Biggest Cat Cracker." *The Lamp,* November 1948, pp. 4–9.

———. "Diesel Locomotives." *The Lamp,* June 1947, pp. 2–7.

———. "Pulling the Pipe." *The Lamp,* April 1945, pp. 16–21.

———. "Truckers' Highway." *The Lamp,* August 1945, pp. 16–21.

———. "Trucking." *Pageant,* July 1946, pp. 26–35.

Lynes, Russell. *The Tastemakers.* New York: Harper & Brothers, 1954.

Maloney, Thomas. "Standard Oil's Great Photo Experiment." *U.S. Camera,* December 1948, pp. 36–39.

O'Neal, Hank, comp. *A Vision Shared: A Classic Portrait of America and Its People, 1935–43.* New York: St. Martin's Press, 1976.

Plattner, Steven W. "How the Other Half Lived: The Standard Oil Company (New Jersey) Photographic Project, 1943–1950." M.A. thesis, George Washington University, 1981.

"A Portrait of Oil—Unretouched." *Fortune,* September 1948, pp. 102–107.

Robbins, Jhan and June. "The Man behind the Man behind the Lens." *Minicam Photography,* November 1947, pp. 52–61, 146–147.

Rosskam, Edwin, illus. "Henderson R6: The Diary of an Oil Well." *The Lamp,* December 1944, pp. 4–7.

Rosskam, Edwin and Louise. *Towboat River.* New York: Duell, Sloan & Pearce, 1948.

———, illus. "Bandbox Refinery." *The Lamp,* February 1945, pp. 4–7.

———. "Muddy and Mean." *The Lamp,* February 1944, pp. 14–18.

Rosskam, Edwin, and Todd Webb, illus. "Big Mamma." *The Lamp,* September 1947, pp. 2–7.

Rotkin, Charles, illus. "Low-Flight Landscape." *Fortune,* April 1949, pp. 103–107.

Sawyer, Roland. "55,000 Documentary Photographs Speak Fluent Americana." *Christian Science Monitor,* 11 May 1949, p. 9.

Stanley, Edward. "Roy Stryker—Photographic Historian." *Popular Photography,* July 1941, pp. 28–29, 100.

Steichen, Edward, ed. *The Bitter Years, 1935–1941.* New York: Museum of Modern Art, 1962.

Stryker, Roy E. "Documentary Photography." In *The Complete Photographer,* edited by Willard D. Morgan, vol. 2, no. 21 (April 1942), pp. 1364–1373.

———. "Documentary Photography in Industry." In *U.S. Camera Annual, 1947,* edited by Tom Maloney, pp. 320–335. New York: U.S. Camera Publishing Company, 1947.

Stryker, Roy E., and Nancy Wood. *In This Proud Land.* Greenwich, Conn.: New York Graphic Society, 1974.

Vachon, Brian. "John Vachon: A Remembrance." *American Photographer,* October 1979, pp. 34–45.

Vachon, John. "Tribute to a Man, an Era, an Art." *Harper's Magazine,* September 1973, pp. 96–99.

———, illus. "Venezuela." *The Lamp,* February 1945, pp. 16–21.

Webb, Todd. *Todd Webb: Photographs.* Fort Worth: Amon Carter Museum, 1979.